years of
bauhaus

KLASSIK
STIFTUNG
WEIMAR

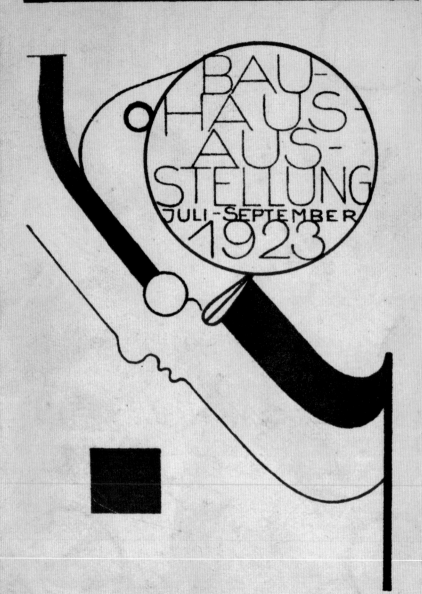

BAUHAUS MUSEUM WEIMAR

The Bauhaus Comes from Weimar!

Edited by
Ute Ackermann, Ulrike Bestgen and Wolfgang Holler

With texts by
Ute Ackermann, Ulrike Bestgen, Anke Blümm, Maxie Götze,
Heike Hanada, Johannes Siebler and Valerie Stephani

HIRMER

KLASSIK
STIFTUNG
WEIMAR

CONTENTS

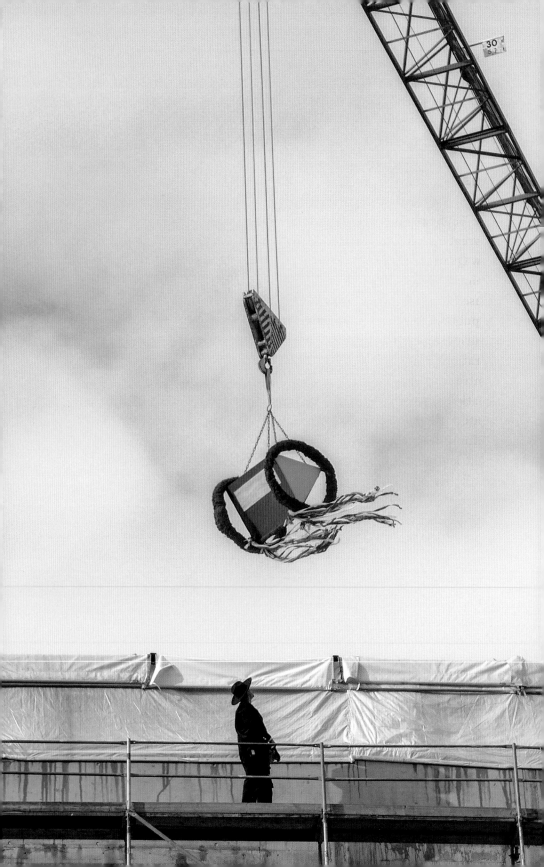

Finally a new Bauhaus Museum for Weimar

The Bauhaus Museum Weimar now stands prominently in a place of great cultural and historical significance. It forms the centre of a new Quarter of Weimar Modernism between the Weimarhallenpark, Weimarhalle, Stadtmuseum Weimar (Weimar City Museum), Neues Museum, the Haus der Weimarer Republik (House of the Weimar Republic) and the former Gauforum, now the headquarters of the Thüringer Landesverwaltungsamt (Thuringian State Office of Administration). Its construction at this site has made the museum the centre of a controversial view towards the changing and ambivalent relationship to modernism since the second half of the nineteenth century. Across the way at the Gauforum, a new exhibition by the Stiftung Gedenkstätten Buchenwald und Mittelbau-Dora (Buchenwald and Mittelbau-Dora Memorials Foundation) will shed light on the system of Nazi forced labour supervised by the Thuringian district leader Fritz Sauckel, who was responsible for coordinating the work assignments from his office. This is where a second exhibition titled *The Gauforum in Weimar: A Legacy of the Third Reich* will also be presented. Weimar has long been a place where the past and present have clashed in a paradigmatic manner and provoked critical discourse. That is why the new Bauhaus Museum does not present an isolated, historicist view of the Bauhaus from its conception in Weimar in 1919 to its years in Dessau until its closure in Berlin in 1933. Rather, it adheres to the premise that the Bauhaus is very much an integral part of a social, political and cultural force field whose reverberations continue to be felt to this day.

In line with the idea of the 'Weimar Cosmos' and the overall museum concept of the Klassik Stiftung Weimar, the Bauhaus Museum is firmly anchored in a network, an all-encompassing 'topography of

modernism', to which the Neues Museum, the Haus Am Horn, the Haus Hohe Pappeln, the Nietzsche-Archiv, the Liszt-Haus and not least the installation *Concert for Buchenwald* by Rebecca Horn also belong. The Neues Museum and Haus Am Horn, in particular, share a close conceptual link to the Bauhaus Museum. The Neues Museum depicts how arts and crafts changed after 1860 against the backdrop of reform movements and the ideas influenced by the philosophy of Friedrich Nietzsche. It sheds light on the liberal development of the Weimar school of painting and drawing and the Weimar art school in a European context, and it portrays the rise of a 'New Weimar' around 1900, an experiment of new beginnings buffeted by the headwinds of reactionism. The exhibition highlights the especially prominent role played by the brilliant Belgian designer, the 'all-round artist' Henry van de Velde. During his most productive years, which he spent in Weimar from 1902 to 1917, his achievements culminated in the Art Nouveau and directly paved the way for the establishment of the Bauhaus by Walter Gropius. The experimental Haus Am Horn, built in 1923, is the result of an architectural and interior design collaboration at the Bauhaus. The building takes centre stage in the exhibition area 'Modern Life' at the new Bauhaus Museum. Other thematic areas of the museum, such as the notion of the 'New Man', the role of theatre and art at the Bauhaus, experimental concepts in education and architecture, the importance of games and celebrations and the role of the Bauhaus directors are presented in short essays by the authors of this guide. They also examine the reasons why the Bauhaus failed to withstand the radical right-wing opposition in Weimar, which, after all, was the birthplace of the first liberal German democracy. It is also important to ask: What remains

of the Bauhaus? Where can we find traces of its ideas and visions today? And where and how does the Bauhaus continue to exert its influence? Tomás Saraceno's installation *Sundial for Spatial Echoes* hanging above the foyer should be interpreted along the same lines. It calls to mind a key question once posed by the Bauhaus from a modern vantage point: 'How can we rethink the world?'

The idea of building a new museum was first brought up in 1990. The Bauhaus expert and head of Weimar's Department of Cultural Affairs Michael Siebenbrodt proposed that Weimar, the birthplace of the Bauhaus, should finally have its own museum dedicated to the accomplishments of the most important German school of design of the twentieth century. At the time, the curatorial responsibility for the material legacy of the Bauhaus was in the hands of the Kunstsammlungen zu Weimar which is part of the Klassik Stiftung Weimar today. Rolf Bothe, director of the art collections from 1992 to 2002, followed up on this idea and established a standing presentation of the Bauhaus collection in 1995. Until 2018 important items of the collection had been displayed in a former carriage house of the late Classical period located on Theaterplatz. From the start, it was clear that the confined space could only serve as a temporary solution, especially as the collection holdings continued to expand in the 1990s and the years of the Weimar Bauhaus from 1919 to 1925 attracted growing interest from the research community. In 2001 the art collections department with support from the Verein der Freunde und Förderer der Kunstsammlungen zu Weimar (Association of Friends and Sponsors of the Weimar Art Collections), now the Bauhaus.Weimar.Moderne. Die Kunstfreunde e.V., began exploring possibilities to enlarge and improve

the Bauhaus exhibition. The assessment by a structural commission, which the Klassik Stiftung Weimar and the Kunstsammlungen zu Weimar reviewed in 2004–2005, strongly supported this goal; a new Bauhaus museum would offer a unique opportunity to tie historical re-examination of the Bauhaus with a reflection on problems symptomatic of our times. Such a museum would serve as a place to 'consider questions of everyday life with a view to future social practices and aesthetic attitudes'. Thanks to a federally financed infrastructural funding programme, of which half the cost was borne by the Free State of Thuringia with additional financing provided by the City of Weimar, the Klassik Stiftung drafted initial plans for the museum as part of the 'Weimar Cosmos' masterplan in 2008. The projects commemorating the ninetieth anniversary of the Bauhaus in Weimar in 2009 underscored how relevant many ideas and ambitions of this pioneering school still are today. The long-discussed matter of the museum's future location was also decided in 2009, whereby the significance of the site in the town's urban infrastructure was expressly emphasised. In the following years, the Bauhaus. Weimar.Moderne. Die Kunstfreunde e.V. and the Department of Architecture and Urbanism at the Bauhaus-Universität Weimar were the two most important trailblazers for ensuring that the new museum was integrated into a cross-institutional 'topography of modernism'.

The exhibition now installed in the Bauhaus Museum is the product of these intensive, content-driven discussions. It provides the impulse for opening an attractive new museum, dedicated first and foremost to visitors, children, youth and adults, local residents and foreign guests alike. A highly ambitious, inclusively orientated

event and educational programme ensures that this new museum will not cultivate a mythos, but rather encourage us to creatively explore the historical Bauhaus and debate the questions evoked by its inspired ideas to help us meet the challenges of the present and future: 'The Bauhaus doesn't only come from Weimar, the Bauhaus lives in Weimar!'

Wolfgang Holler

General Museum Director
Klassik Stiftung Weimar

This book is part of a nationwide programme commemorating the one hundredth anniversary of the Bauhaus, in which over a dozen federal states and more than one hundred municipalities are participating. Bauhaus monuments are popular attractions to visitors everywhere. New museums are opening their doors. With their functional and aesthetic qualities, Bauhaus designs enjoy cult status around the world. And yet, even after one hundred years, our business with the Bauhaus is far from finished. This indispensable celebration of our cultural heritage requires us to examine the complex ambivalence with which the Bauhaus has shaped the modernist project – spanning trades and technology, arts and crafts, cosmopolitanism and esotericism and paternalism and social experimentation. And these are only a few of the aesthetic and political fields in which the Bauhaus has exerted its influence. In the Bauhaus Manifesto, Gropius proclaimed: 'The ultimate goal of all creative activity is the building.' With this maxim in mind, we not only think of steel and glass and white cubes during this commemorative year. We also think of the building, the construct, of Bauhaus ideas, which, like the entire modernist project, remains compellingly unfinished and open-ended – much like the countless questions that connect our crisis-ridden times in the twenty-first century to the Bauhaus. Questions concerning the freedom of art and education, the equitable distribution of global resources, the relationship between the sexes, affordable housing, liveable cities and the dominance of smart technology in a modern, post-humanist society.

Experimentation and remembrance – the Kulturstiftung des Bundes (Federal Cultural Foundation) has continually striven to

support both ideas in its funding activities in this Bauhaus com-memorative year. Out of the 17 million euros allocated towards funding Bauhaus-related projects, a total of 5 million alone were invested in the 'Bauhaus Agents' programme. The focus here is on cultural education and establishing sustained collaboration be-tween Bauhaus museums and young people. The participants are encouraged to develop their own positions on how to build houses and cities, how to dance, take photos, eat and dress, to envision how one might write and speak in the future – and to explore what role the Bauhaus can play in all of this.

The Kulturstiftung des Bundes wishes to thank the Klassik Stiftung Weimar under the direction of Hellmut Seemann; general museum director, Professor Wolfgang Holler; the head of the Bau-haus Museum Weimar, Dr Ulrike Bestgen; the curators Ute Acker-mann and Dr Anke Blümm; the architect Heike Hanada and her team, as well as all the other project participants, especially the 'Bauhaus Agents' for organising the collection presentation *The Bauhaus Comes from Weimar*. We wish this project great success and a large audience, as we do this publication and many readers.

Hortensia Völckers

Executive Board / Artistic Director

Alexander Farenholtz

Executive Board / Administrative Director

The Bauhaus Museum Weimar has opened its doors right on time for the commemorative festivities and can now be presented to the public. This is an important day for the City of Weimar and the Free State of Thuringia. The long years of improvisation at the old Bauhaus Museum are finally over. In addition to a fascinating exhibition of the Bauhaus collection, the new museum now offers all the modern services and educational activities which characterise a modern museum. Echoing the questions posed by the Bauhaus one hundred years ago, the museum asks 'How will we live, how will we settle, what form of community do we want to aspire to?' Questions which are sure to elicit important and exciting insights in dialogue with the visitors.

The long discussion about the future location of the Bauhaus Museum was an expression of society's grappling with the challenges of building a museum in a historical setting, a museum that now stands self-confidently alongside the adjacent Weimarhallenpark, the former Gauforum, the student residence hall 'Langer Jakob' from the GDR era and the Neues Museum Weimar. It is a special location which reflects the ambivalence of modernism in Weimar's urban infrastructure, promising to offer a unique perspective in its historical neighbourhood with various theme-based museum programmes, as well as the obligation for the Klassik Stiftung Weimar to continue exploring the various aspects of this topic in the future.

The opening of the Bauhaus Museum is not only of great significance to the City of Weimar. In fact, all of Thuringia was a mecca of modernism. The influence of the Bauhaus on the 'New Building' style of the 1920s and 1930s can be found in numerous places throughout the state. Local architects and Bauhäusler were

actively involved in building private and public commemorative sites and buildings featuring various facets of modern architecture and design. There are many fascinating places on Thuringia's grand tour of modernism which I cordially invite you, dear reader, to visit and see for yourself.

But for today, let me conclude by extending my heartfelt thanks to everyone who helped make the Bauhaus Museum a reality, especially the architect and her team, the Klassik Stiftung Weimar and its committed staff in the building and museum departments, the exhibition designers, the Bauhaus.Weimar.Moderne. Die Kunstfreunde e.V. and all the other supporters and sponsors who believed in the construction of this new museum for so many years and worked to make it happen. To you all, the Free State of Thuringia owes its deepest gratitude.

Benjamin-Immanuel Hoff

Head of the Thuringian State Chancellery and Minister of Culture, Federal and European Affairs Chairman of the foundation board of the Klassik Stiftung Weimar

THE BAUHAUS MUSEUM – LOCATION AND CONCEPT

Museum façade, east side, to the right the Gauforum, now the State Administration Office, Haus 2, 2018

THE NEW BAUHAUS MUSEUM WEIMAR is part of the masterplan 'Weimar Cosmos', which thematically and conceptually interconnects all museums, historical sites and departments of the Klassik Stiftung Weimar. Its primary task is to present the artistic and aesthetic trends in modernism from 1919 to 1945 and always with regard to the present and in reference to international developments. The exhibition *Van de Velde, Nietzsche and Modernism around 1900* at the Neues Museum Weimar corresponds to the presentation in the Bauhaus Museum, as does the newly installed exhibition in the Haus Am Horn, which likewise highlights themes closely related to the Bauhaus Museum.

After a long discussion and exhaustive study which identified ten potential locations, the Klassik Stiftung Weimar decided to build its new museum on the former Minolplatz on the periphery of the Weimarhallenpark. This location marks the intersection of several historical axes. The Weimarhallenpark, originally established during the Baroque and Goethe era, was the centre of a major cultural project in the 1920s. It was converted into a public park with outdoor swimming pools and a stadium built nearby. Under the direction of the National Socialists, construction of the monumental Gauforum began in 1936 and was designed to symbolise Nazi power and its racialist doctrine. The Neues Museum Weimar, located near the Bauhaus Museum, was Thuringia's first museum, built from 1863 to 1869. Not only has it staged important exhibitions of modern art throughout its history, it was also used as the temporary headquarters of the Nazi Gauleiter of Thuringia and was slated to be demolished under the East German regime. In its new exhibition,

the Neues Museum highlights the formative years prior to the Bauhaus, revealing an era that accomplished far more than merely laying the groundwork for the Bauhaus. Looking east from the Bauhaus Museum, one catches sight of the 'Langer Jakob' (Tall Jacob), a high-rise building from the 1970s which is still used as a student hall of residence.

Due to the geographical proximity to these sites and taking into account the reorganisation of the Neues Museum, the exhibition of the Bauhaus Museum aims to provide numerous examples that highlight the ever-inherent contradictions of modernism. Visitors will have the opportunity to view museum-like presentations in the immediate vicinity. For example, the Museum of Forced Labour during National Socialism planned by the Stiftung Gedenkstätten Buchenwald und Mittelbau-Dora (Buchenwald and Mittelbau-Dora Memorials Foundation) will open in the Gauforum in 2020. The Bauhaus-Universität Weimar plans to stage an exhibition on National Socialism in Weimar there as well. In cooperation with the association Weimarer Republik e.V., the City of Weimar will be opening a Haus der Weimarer Republik – Forum für Demokratie (House of the Weimar Republic – Forum for Democracy) in the former Bauhaus Museum on Theaterplatz in 2020. Moreover, all of these institutions and organisations are working together to develop a new Quarter of Weimar Modernism that offers touristic, historical and contemporary perspectives.

The Bauhaus Museum sees itself as a vibrant site of education open to tourists, visiting researchers and students, as a forum for discussions and events, as a centre of activity and laboratory where research, collection, presentation, education, experimentation and reflection overlap and interweave.

This concept defines the museum as a social location, a platform which not only introduces visitors to the sensual and practical aspects of expressive forms interactively – as is so often the case in museum presentations – but also invites them to use the museum to examine matters related to their daily lives. Against the backdrop of globalisation and economisation, the primary goal is to make the institution of the museum a place where visitors can gain

experience, learn and reflect in a dynamic environment full of innovative projects.

And this is how the Bauhaus Museum ties the history of the Bauhaus to questions of how to design our living environment today and in future. The starting point and thematic thread of the exhibition is the question the Staatliches Bauhaus posed in 1924: 'How will we live, how will we settle, what form of community do we want to aspire to?' This is no longer the model today. Rather, one hundred years later, we look to the Bauhaus for solutions to the profound social and political changes we face, also with respect to technical and digital developments and aspects of ecology, participation and sustainability. With the ideals of the Bauhaus in mind, we can critically compare our understanding of community and individual lifestyles, the aestheticisation of daily life and tendencies of individualisation and withdrawal.

The architectural design of the museum by Heike Hanada in cooperation with Benedict Tonon brilliantly renders these different layers. The park and ground-floor level of the museum form a bridge to various historical levels and a junction between the downtown and the Weimarhallenpark. Both levels are publicly accessible. Inside there is a café, project and event room, an introduction to the Bauhaus and a city model depicting the new cultural quarter currently under development.

The permanent exhibition on the three upper levels presents the central themes of the Bauhaus, its ideas, processes and references to daily life. Depending on the displayed objects, the themes create narrative threads which intersect at certain points: 'The New Man', 'School as Experiment', 'Modern Life', 'New Living' and the 'Bauhaus Stage as an Experimental Field'. In the topmost level, we discuss the question of 'What remains?' based on selected achievements by the former Bauhaus directors Walter Gropius, Hannes Meyer and Ludwig Mies van der Rohe. Contemporary artists, architects and designers will be invited to present their view of the Bauhaus and its lasting influence in a special project room.

The basis of the exhibition are the objects or object groups of the Bauhaus collection and the Design-Sammlung Ludewig (Ludewig

Design Collection) with supplementary media-based installations. A media guide will be gradually expanded to enhance the presentation but will by no means replace the original objects. In times of increasing digitalisation, encountering and interacting with the historical objects promises to be far more stimulating to the imagination. ULRIKE BESTGEN

The art in the new building

There is a long tradition in Weimar spanning hundreds of years of inviting contemporary artists to personally create site-specific art works in museums or the Weimar Stadtschloss (City Palace). The Bauhaus Museum Weimar continues this time-honoured tradition, choosing artists who have designed impressive spatial installations which directly respond to the architecture of the new museum.

The first installation, *Sundial for Spatial Echoes*, hovering in the air in the foyer, was designed by Tomás Saraceno, born in 1973 in San Miguel de Tucumán, Argentina, who now lives and works in Berlin. The work was selected for the Bauhaus Museum by a jury of experts. Their decision ultimately came down to how well it reflected the unique harmony of art and science and of nature and culture – a characteristic that Walter Gropius had found so fascinating in Goethe.

Very much aligned with the Bauhaus ideas, the *Sundial for Spatial Echoes* embodies an interdisciplinary approach that combines aspects of physics, biology, sociology and urban studies. The work creates a dynamic, reflective atmosphere with its cloudlike landscape of interwoven, web-like fibres. Tomás Saraceno's artistic research and aesthetic practice are driven by his endless desire to develop and create utopian structures and address sociological and environmental issues. In highlighting the character of clouds, the sun and webs, he pointedly alludes to the specific challenges of a visionary city in the globalised world of the twenty-first century.

For the open space between the first and second floors, the media artists of Studio TheGreenEyl (Berlin/New York) teamed up

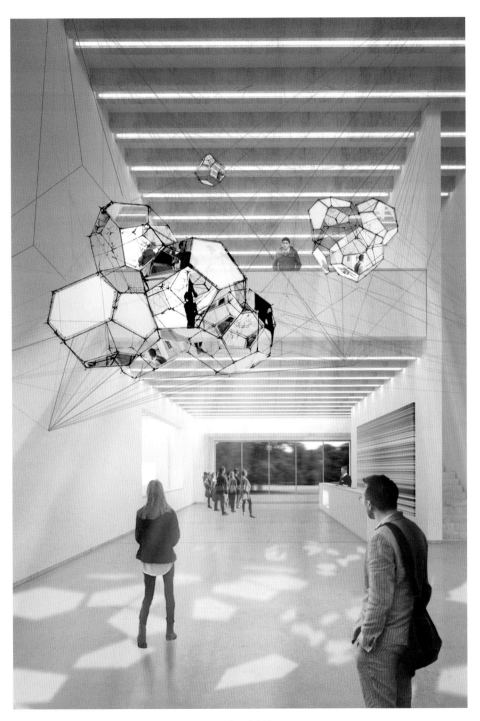

Tomás Saraceno, *Sundial for Spatial Echoes*, design, 2018

TheGreenEyl, *Rare Moments of Light* (*Seltene Lichtmomente*), design, 2018

with the exhibition designers at Holzer Kobler Architekturen (Zurich/Berlin) to create the installation *Rare Moments of Light*. The work refers to the famous Bauhaus Manifesto of 1919, drafted by Walter Gropius, with a cover page featuring a woodcut by Lyonel Feininger. Published in spring 1919 and circulated around the world, it inspired many young people to come to Weimar and study at the Bauhaus. Its content is both visionary and utopian, its language is expressionistic and celebratory. Following the devastating experience of the First World War and the charged atmosphere of the November Revolution in 1918, the Bauhaus Manifesto offered the prospect of a promising future – one that invited young people to become a part of a community that was unafraid to address the urgent challenges of the times. A key aspect was the collective effort in 'building the future', the 'crystalline symbol of a new and coming faith'. Reformers and innovators have long and frequently employed the symbolism of light throughout history. Drawing on this symbolism and the central tenets of the manifesto, the artists of Studio TheGreenEyl have created a media and light installation that virtually breathes life into the words. The grand aspirations of the Bauhaus light up like a promise and become part of a large process moving forward. ULRIKE BESTGEN

bauhausmuseumweimar

Every museum is a prototype. Every aspect – the form, location, expression – precisely corresponds to the requirements placed on the museum. At the same time, it bears the ideas, the signature of the respective architect. A good museum conveys this signature – but only to a certain extent. It also ensures that the respective content has the space it needs to present and display itself. This idea is supported by the decision to expose the T-beam ceiling construction. Space and construction merge into a comprehensive order.

The idea lies in the stringent abstraction of its form. Fleshing out this spatial idea, condensing it to its core, requires no direct

outward message. The idea exists by itself, expressed in its interior design concept. It is strengthened further when bound within a body. The building itself is reduced to a simple geometric form. The enclosing shell of light-grey concrete lends the cube stability and dynamic solidity. The monolith stands firmly planted between the downtown and the Schwansee Park. Its position in space is clearly and simply defined. Its body of poured concrete creates structure and space within. The brutal intervention in the natural topography – the loss of the Asbach valley, which was filled for the construction of the Gauforum – is not glossed over, but rather intentionally emphasised and integrated into the urban planning concept. With this new building at the park's edge, the interpretation of the topography extends all the way to the Gauforum. The colonnades, which were intended to line the street and plaza, are now confronted with the open, flowing space of the original Asbach valley. The rupture is underscored in two ways: the emphasis on the difference in elevation of the slope and the annexation of the terrain by the Gauforum using free forms of 'nature'. The result is a space that interconnects different places, recognising the foreignness of the Gauforum, yet including its traverses and colonnades into the concept without falling victim to its Fascist spatial principles.

In line with the urban planning concept, the interior design of the museum is orthogonally positioned in relation to the park. The arrangement of the main stairs corresponds to the topographical slope of the outside terrain. Visitors ascend a succession of inter-changing open spaces and staircases until finally they arrive at the top floor, where they are presented with an unobstructed view of the park.

The cascading staircases are encased by ceiling-high walls and function as free-standing, enclosed bodies in the interior space. For a brief moment, they draw the viewers' attention inward, before releasing it again as visitors enter the open exhibition levels. This interplay of flowing and framed room sequences serves to highlight the exhibition's thematic division and thereby enhances its organic structure. Furthermore, several open spaces are diagonally arranged

to provide alternative lines of sight and enable visitors to more easily orientate themselves in the building.

The museum is illuminated. From a distance, its sheer cubature lends character to the public space. When night falls, the structure rises from its stone pedestal, basking in the light of twenty-four radiant strips. The monolithic spatial sculpture oscillates on the surface. The real and imaginary spaces intersect in narrow seams of light. Changing light frequencies transform the rugged concrete body into a brilliant, pulsating event. For a moment, our perception of time and material is suspended as its concrete features fade and vanish. HEIKE HANADA

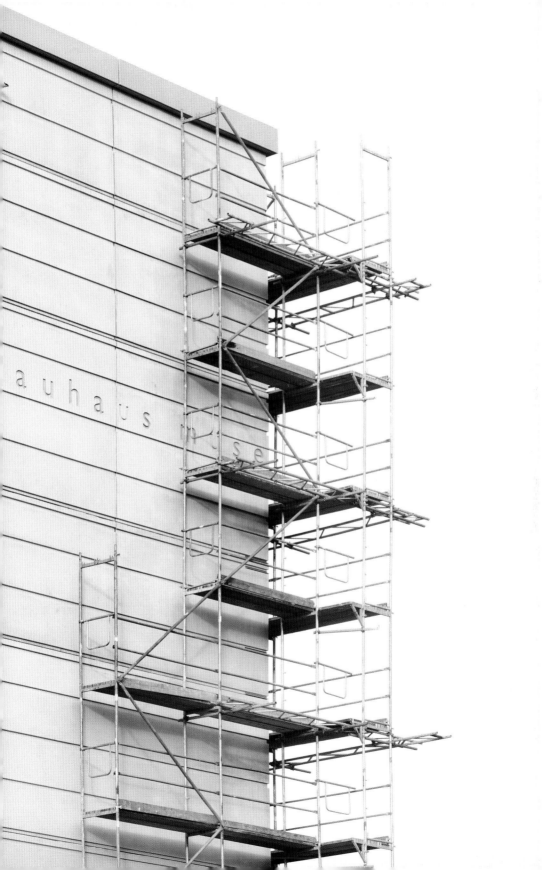

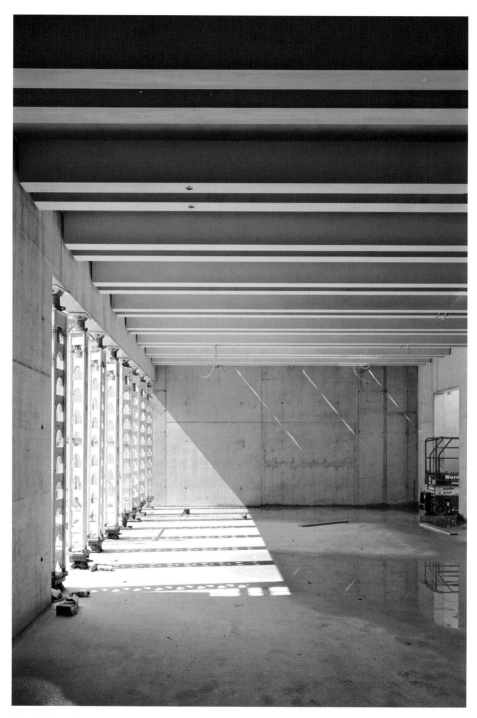

Completion of the first ribbed slabs in the lower level, spring 2017

The Bauhaus Museum Weimar: A construction chronology

PRESS DEPARTMENT AND THE DEPARTMENT OF CASTLES, GARDENS, BUILDINGS OF THE KLASSIK STIFTUNG WEIMAR

8 May 1995 The Bauhaus Museum Weimar opens with a permanent exhibition in the Kunsthalle on Theaterplatz.

2000 The Weimar architect Peter Mittmann carries out a feasibility study on the construction of an annex to the Kunsthalle on Theaterplatz, sponsored by the Bauhaus.Weimar.Moderne. Die Kunstfreunde e.V. It is not possible to secure the necessary funding because the Kunstsammlungen zu Weimar is a municipally curated collection.

2003 The Kunstsammlungen zu Weimar is merged with the Stiftung Weimarer Klassik.

2005 A structural commission evaluates the Klassik Stiftung Weimar and recognises the necessity of an expanded Bauhaus museum.

Spring 2008 The decision is made to establish the advisory committee Conception of a Bauhaus Museum. In view of the inadequate display and storage of Bauhaus objects at Theaterplatz, the Thuringian Ministry of Education and Cultural Affairs (TKM) urges all parties to quickly commence planning.

Spring 2009 Following the creation of a special financing programme, the Federal Government Commissioner for Culture and the Media (BKM) Bernd Neumann and the TKM launch a site investigation for the new museum. Out of ten possible locations, the decision comes down to Frauenplan, Minolplatz, Theaterplatz and the Bauhaus-Universität student dining hall.

24 March 2010 The mayor of Weimar appoints an independent commission of experts to find an amicable solution concerning the future location of a Bauhaus museum.

20 May 2010 The commission selects the Minolplatz next to the Weimarhallenpark and the Gauforum. Building the museum at this site would create new impulses for the town's infrastructure. The goal should be to improve pedestrian access to the historical part of town and facilitate a more favourable connection between the historical centre and the north quarter of downtown Weimar.

17 September 2010 The foundation board of the Klassik Stiftung Weimar confirms the commission's decision for the Minol car park as the site for a new Bauhaus museum.

Early 2011 A two-phased architectural design competition is announced, and a jury of experts and assessors comprised of federal, state, municipal and foundation representatives is appointed. A total of 536 proposals are submitted from around the world.

29 December 2011 The cost ceiling is set at 21.78 million euros.

29 November 2011–1 December 2011 First jury session, 27 works are selected for further development in the second phase.

13 March 2012–15 March 2012 Second jury session, selection of 2 second-place winners, 2 third-place winners and 3 honourable mentions.

16 March 2012–8 April 2012 The 27 proposals of the second phase of the competition are publicly displayed at the Neues Museum Weimar.

30 March 2012 Public hearing on the competition in the auditorium of the Bauhaus-Universität Weimar.

25 April 2012 At the recommendation of the competition's jury, the four prizewinners are asked to further develop their designs in accordance with VOF contract regulations for freelance services.

May 2012 The Weimar city council's building and environmental committee expresses its support for building the Bauhaus Museum at the site adjacent to the Weimarhallenpark and Gauforum as recommended by the expert commission.

25 June 2012 The proposal by Professor Heike Hanada in cooperation with Professor Benedict Tonon is selected as the winner of the architectural design competition.

13 July 2012 Introduction: Heike Hanada, along with Benedict Tonon, is commissioned to proceed with the planning and implementation of the revised competition proposal. The revised competition design is implemented by the architect.

12 December 2012 Approval of the infrastructural development plan of the City of Weimar.

28 January 2013 Numerous residents of Weimar discuss the implementation and concept of the Bauhaus Museum with the Klassik Stiftung Weimar (as the contractor) and the architect.

18 September 2013 The Weimar city council approves the building proposal 'Bauhaus-Museum/Am Weimarhallenpark' and the fifth land-use plan amendment 'Bauhaus-Museum/ Am Weimarhallenpark'.

October–November 2013 Both the building proposal 'Bauhaus-Museum/Am Weimarhallenpark' and the fifth land-use plan amendment are publicly displayed at the municipal administration office.

13 November 2013 The city council agrees to conclude an urban planning contract between the City of Weimar and the Klassik Stiftung Weimar and to draft a zoning plan for the new museum on the brownfield site of the former Minol car park. Streets will have to be re-routed, and the entire area must be rezoned in accordance with urban development plans.

29 January 2014 The city council approves the zoning plan 'Bauhaus-Museum/Am Weimarhallenpark'.

30 January 2014 A cost and financing contract is signed by the City of Weimar and the Klassik Stiftung Weimar, stipulating the creation of site-developmental and outdoor facilities, the installation of supply and utility lines and groundwater monitoring around the Bauhaus Museum.

19 March 2014 Following a legal review by the municipal administration, a public petition to relocate the Bauhaus Museum Weimar is turned down on the grounds that the content of the petition, that is, the request to relocate the building, does not fall under the jurisdiction of the city council.

July 2014 The preliminary planning phase and negotiations to adjust the financing budget to 22.65 million euros are concluded.

26 August 2014 The City of Weimar commissions the Zurich-based firm Vogt Landschaftsarchitekten to oversee the landscape design of the museum.

18 September 2014 A second public petition is submitted to allow Weimar residents to decide whether to immediately and permanently cease financing of the new Bauhaus Museum Weimar with municipal resources. Because this move would violate contracts already in place between the City and the Klassik Stiftung Weimar and no adequate replacement cost and financing plan was submitted, the municipal administration declines the petition.

November 2014–January 2015 Three underground oil tanks are removed from the former Minol petrol station. The concentration of chemicals released during the extraction of the tanks is tested numerous times and found to pose no health risks as they disperse into the outside air. The concentration of the released substances is monitored as a precaution throughout the entire construction phase.

1 December 2014 The building application is submitted to the City of Weimar.

16 February 2015 Construction begins to re-route traffic connections for the museum.

31 March 2015 The City of Weimar issues the building permit.

13 August 2015 The new connection road between Asbachstrasse and Ernst-Thälmann-Strasse is opened to traffic. Work begins on the new entrance to the Weimarhalle underground car park on the west side of the State Office of Administration.

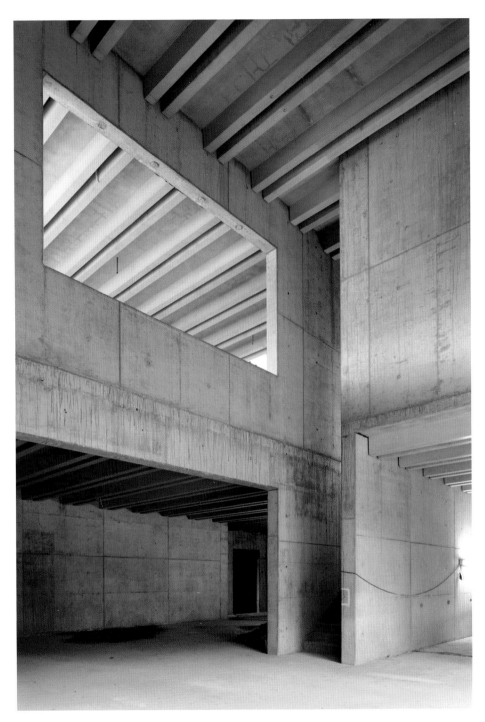

View of interior windows of the foyer, summer 2017

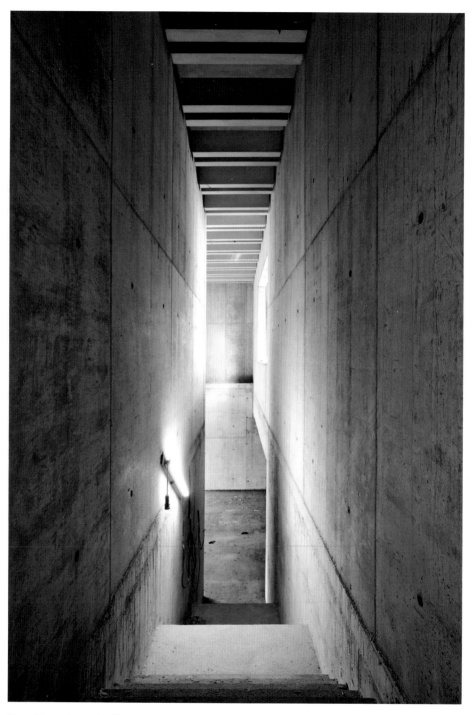

Cascading staircase leading to the future lounge, summer 2017

3 November 2015 Excavation of the museum's foundation begins.

10 November 2015 Ground-breaking ceremony by the chairman of the foundation board, Prof Dr Benjamin-Immanuel Hoff, Minister for Cultural, Federal and European Affairs and head of the Thuringian State Chancellery, together with federal, municipal and Klassik Stiftung representatives.

21 December 2015 Accident occurs during drilling operations resulting in personal injuries. Construction is temporarily halted. The sample façade is installed.

December 2015 Following an open competition for design proposals, the firm Holzer Kobler, Berlin/Zurich, receives the contract to design the exhibition in accordance with VOF contract procedures.

Winter 2016 Further ground testing is conducted, and contaminated excavated material is removed.

Spring 2016 As the fourth and final phase of the road construction work, the northern section of Weimarplatz is blocked to traffic and completely redesigned to connect with the already completed sections (Rathenauplatz and the entrance to the underground Atrium car park).

19 February 2016 Because some of the trees on the site have to be cut down and replacements can only be planted on the premises of the new museum when the garden and landscaping phase begins in 2019, substitute measures are carried out at a different location in agreement with city authorities and the Klassik Stiftung.

28 October 2016 The symbolic cornerstone is laid by Hellmut Seemann, President of the Klassik Stiftung Weimar, together with Prof Monika Grütters, Minister of State for Cultural and Media Affairs, Prof Dr Benjamin-Immanuel Hoff, Stefan Wolf, mayor of Weimar, Wolfgang Tiefensee, Thuringian State Minister of Economy, Science and the Digital Society and Heike Hanada.

6 December 2016 Presentation of the preliminary landscape design by the City of Weimar in agreement with the Klassik Stiftung.

16 December 2016 The Klassik Stiftung commissions a contractor to oversee the shell construction of the Bauhaus Museum Weimar. The construction is to be completed by the end of 2017.

23 December 2016 Excavation of the foundation is completed.

9 January 2017 Work on the shell construction begins.

January 2017 After the building site is readied, the Klassik Stiftung begins laying the utility mains which will later be concealed beneath the base slab.

August 2017 The firm Holzer Kobler submits its proposal for the exhibition design.

21 August 2017 Information event on the planned outdoor facilities at the Weimarhalle. The installation of the electrical and technical systems begins.

30 November 2017 One year after the symbolic cornerstone was laid, 280 guests attend the roofing ceremony for the Bauhaus Museum Weimar, marking the completion of the shell construction.

December 2017–March 2018 Due to design-related considerations, the architect proposes replacing the originally planned glass encasement with a fair-faced concrete façade. As the contractor, the Klassik Stiftung commissions the architect to submit plans for an alternative façade which can serve as the basis for reaching a decision. In December 2017 the contractor decides for a fair-faced concrete façade and submits this variant to the funding providers. In agreement with the City of Weimar, the decision on the final design of the façade is to be made by the foundation board of the Klassik Stiftung based on the recommendation of the jury of experts from the VOF procedure.

January 2018 The 'Art in Building' competition invites eight renowned artists and artist groups to submit proposals.

Spring 2018 The outer walls of the shell are fitted with insulation. For a time, the building appears black on account of the dark colour of the insulation material. Inside technicians complete the installation floors, whilst roofers begin sealing the roof surface.

April 2018 The prefabricated concrete façade elements are assembled on the south side of the building.

June 2018 The jury of the 'Art in Building' competition, chaired by Prof Dr Wulf Herzogenrath, convenes at the Neues Museum Weimar. The jury awards first prize to Tomás Saraceno and recommends his proposal for realisation.

Summer 2018 The interior builders commence their work. Screed, dry wall, plaster, tile and painting work takes place on all levels simultaneously, and tiling is laid in the sanitary facilities. Doors are installed; carpentry and metalworking activities begin.

28 August 2018 The City commences landscaping measures around the premises, starting with the area east of the museum. On 1 September construction begins on the recessed path to the park. At the same time, work on the heating and cooling ducts begins.

October 2018 Whilst the interior building work proceeds, technicians install fine technical and electrical fixtures. Air vents, spotlights, smoke detectors, etc. are installed.

1 November 2018 Construction work in and around the Bauhaus Museum is suspended at 4 pm after workers discover ammunition (a mine, two hand grenades, two pistols) dating back to the Second World War. The bomb disposal team gives the 'all clear' after determining that the weapons are not live and pose no threat.

6 November 2018 The foundation board of the Klassik Stiftung announces its decision on the design of the façade. The board concurs with the jury's recommendation to furnish the building with a prefabricated exposed concrete façade and horizontal strips of glass lighting.

13 December 2018 The final element of the façade is installed. The horizontal light strips which lend the building an evenly distributed rhythmic pattern have been installed on the south- and west-facing sides.

17 December 2018 Installation of the display cases on the third floor begins along with the exhibition architecture.

Winter/spring 2019 The last firms responsible for the final touches commence their work. Handrails, counters and in-built furniture are assembled and installed. The guidance system is attached to the walls. Work on the outdoor facilities is temporarily suspended on account of the weather.

January 2019 The air conditioning system begins operation.

March 2019 Tomás Saraceno instals his art work in the museum foyer.

March 2019 All technical and building inspection measures are completed so that the museum may commence operation. The art works are arranged in the display units in the exhibition areas.

5–7 April 2019 Grand opening weekend of the new Bauhaus Museum Weimar.

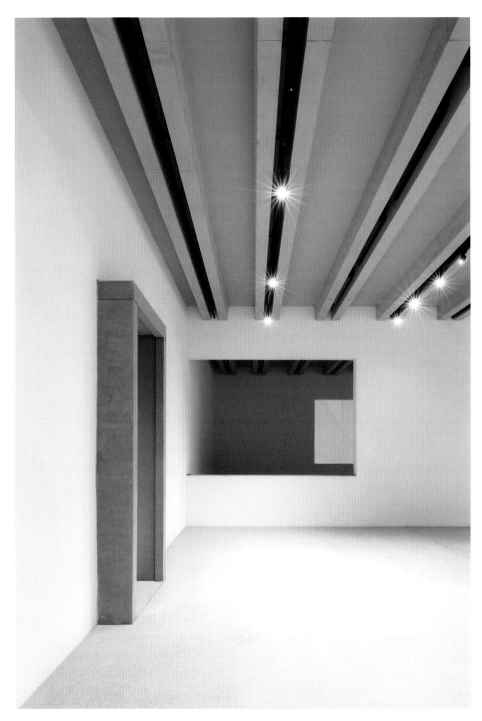

View through the exhibition rooms, January 2019

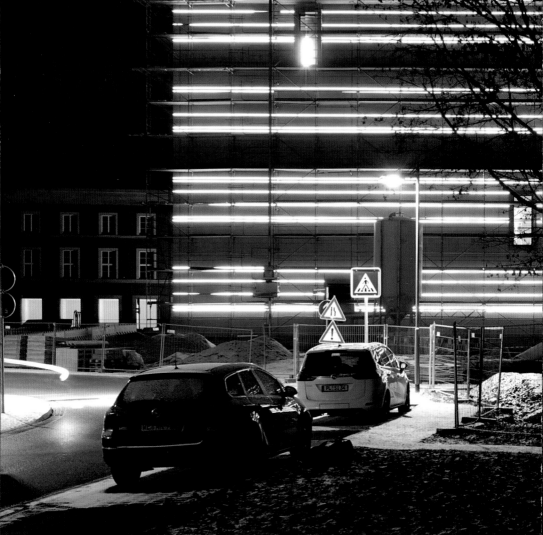

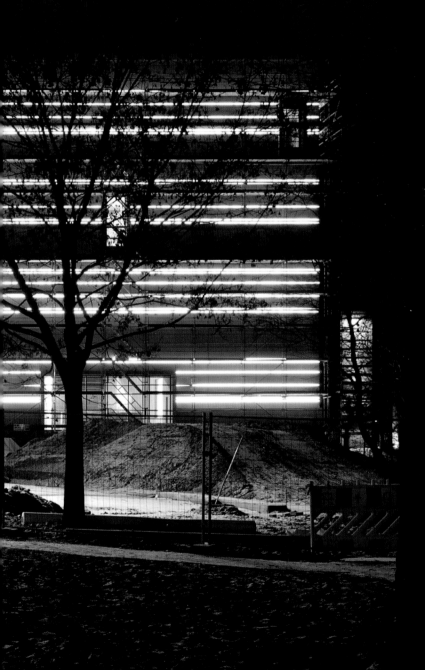

THE NEW MAN

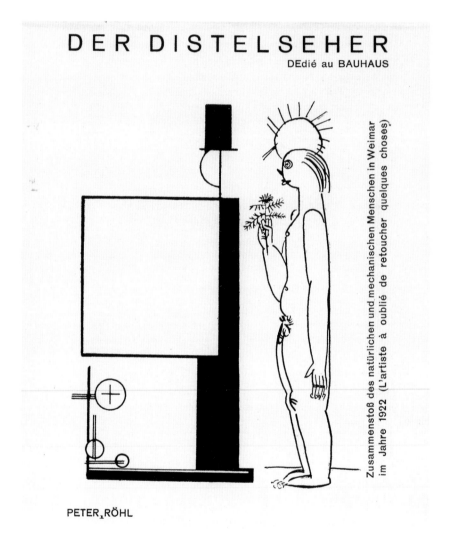

Karl Peter Röhl, *Der Distelseher* (*The Thistle-Seer*), from Theo van Doesburg (ed.), *Mécano*, no. 2, 'Blue, Blauw, Blau, Blue' (Leiden, 1922)

IN THE WORDS OF WALTER GROPIUS in 1919, 'a broad, all-encompassing art arises from the intellectual unity of its time, it requires the most intimate connection between the environment and the living human being. Man must first be well designed; only then can the artist create a beautiful frock for him. The human race of today must begin to rejuvenate itself from the ground up, to create a new humanity, a standard way of life for the people. Then art will come.' In contrast to the Werkbund, which hoped that good design would inspire improvement in people, the Bauhaus initially concentrated more on designing human beings themselves than on objects or products. The pedagogical programme of the Bauhaus focussed on making the individual a member of a community.

The search for a way of life that was universally applicable and corresponded to modern times had already begun in the nineteenth century. People seemed ill-prepared to meet the new challenges of the times. They were forced to grapple with the consequences of the burgeoning Industrial Age and develop new strategies for leading a modern life. And thus, the idea of forming a New Man was born, one who was capable of enduring modern life.

Following the devastating events of the First World War, which saw the industrial slaughter of millions, many had lost faith in modern technology. What alternatives could people turn to in the face of unchecked progress? Were they supposed to turn inward and swear off modernism altogether? Or place their complete trust in the future?

The term *New Man* is by no means a clearly defined ideal. In fact, there were a number of different concepts making the rounds at the time – ideologies, values and nationalistic and socialistic concepts of varying origin.

Nietzsche's topos of the *Übermensch*, the philosophies of the reform and youth movements, the utopian-socialistic notions of society of the early Soviet Union and the semi-religious ideals of self-liberation were all competing against one another. The Wandervogel movement rejected the dictates of reason, the world of adults and obligations. As a countermovement to industrialism, it celebrated nature and individualism. The community-focussed concept of the New Man included aspects of social action, communication and lifestyle. In this respect, life in rural communities and technology-friendly metropolises were both viewed as potential models of modern living.

These concepts were also discussed at the Bauhaus. Johannes Itten advocated a holistic pedagogical programme in which artistic individuality was superior to all else and the ideal of community was sacrosanct. Others, such as the conservative nationalist Hans Gross, believed that 'German art' could serve as a meaningful theme for a common form of living. Constructivism, on the other hand, celebrated the abstract technicity of the future in which humanity could accomplish the modernist project through mathematical reasoning.

Karl Peter Röhl's caricature in the De Stijl journal *Mécano* directly referred to the contradictory approaches proposed by Johannes Itten and the De Stijl movement. The natural man, naked and holding a thistle in his hand, confronts the mechanical version of himself donning a top hat. While the thistle-holder stands naked in the sunshine contemplating the plant, a square man in a top hat rolls directly towards him. Their collision presages the moment when the Bauhaus had to decide either to return to its roots in self-contemplation – as Itten favoured – or open itself to technology, industry and mechanical design, as reflected in the new Bauhaus motto calling for a new unity of art and technology.

Starting in 1922, this new Bauhaus slogan emphasised the school's commitment to understanding and shaping the world by promoting a modern, human-based design. Function, material and economics were to drive the development of this new design. This 'scientific' concept corresponded to the search for a universal

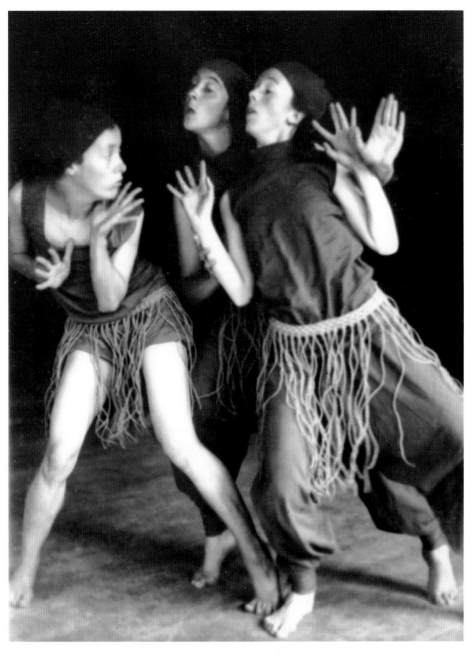

Tänze der Loheländerinnen. *Rufen – Stimmen des Frühlings* (*Dances of the Loheland Women: Calling – Voices of Spring*), 1919–20

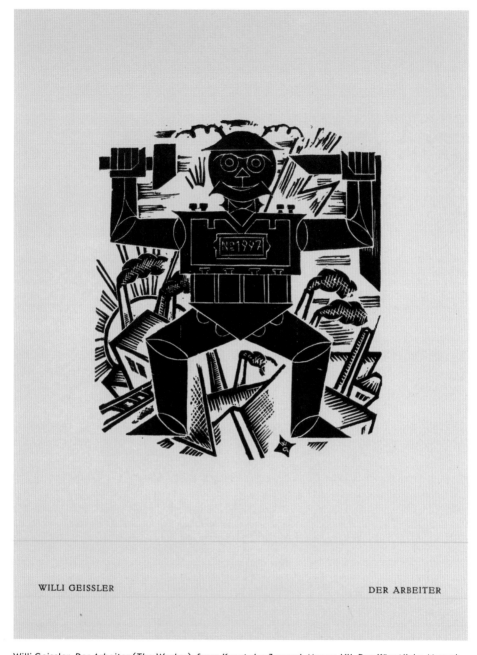

WILLI GEISSLER

DER ARBEITER

Willi Geissler, *Der Arbeiter* (*The Worker*), from *Kunst der Jugend, Mappe VII, Der Künstliche Mensch* (*Art of Youth, Portfolio VII, The Artificial Man*), sheet X, 1923

standard of things and spaces, their optimisation and formation as norms, which ultimately established it as an ideology in its own right. UTE ACKERMANN

Reform and revolution

Around the mid-nineteenth century the German life reform movement aimed to mitigate the negative effects of industrialisation and the resulting changes in society with practical alternatives and utopian social concepts. The movement centred on liberating the individual and converting the body as an earthly vessel into the locus of the soul. The proposed methods included vegetarianism, the temperance movement, alternative pedagogical concepts, dress reform, the settlement movement and physical edification. All of these ideas served to portray the human being as a complex, holistic, physical-spiritual system.

Physical education played a central role in the life reform movement and was initially practised by a small group of people with respect to artistic self-expression. Gymnastics and expressive dance of various schools, as well as body-conscious living and healthy nutrition were regarded as integral elements of modern lifestyle after the turn of the twentieth century.

'Things' underscored the physical imperfections of human beings. However, many believed that with sufficient engineering talent and ingenuity, things could be used to their advantage. It was conceivable that technology could overcome the limitations of the body. The idea was that future human beings would become machine hybrids who would reside in living machines. This vision was met with resounding criticism and was frequently caricatured in certain circles of culture.

Nietzsche's idea of the *Übermensch*, which he formulated in his treatise *Thus Spoke Zarathustra*, was thrilling to young adults in the early years of the twentieth century; the war edition of *Zarathustra* accompanied young soldiers to the trenches of the First World War. These young men joyfully marched off in the ludicrous hope that

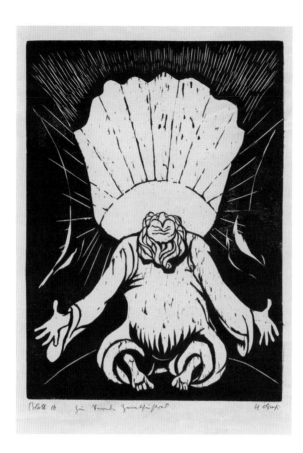

Hans Gross, *Das Gebet an die Mittags-Sonne* (*The Prayer to the Midday Sun*), from *Zur Vorrede Zarathustras* (*On the Preface to Zarathustra*), sheet 10, 1921

war would create a new kind of human. They returned broken and disillusioned. The spirit of Expressionism now filled the air with lofty ideas and cosmic visions. Artists intervened in the political arena. Anarchistic utopias assessed the defeat on the battlefield as a chance for a fairer world in which workers and soldiers would assume the mantle of governance. This vision existed for one historical moment when the Bavarian Soviet Republic was founded in 1919, only to be violently crushed four weeks later. UTE ACKERMANN

Norms

By 1919 women in Germany had secured the right to vote, and by 1915 at the latest, they were working in factories and workshops whilst the soldiers were off fighting in the First World War. Women played an active role in the political campaigns of the November Revolution. They wore their skirts and their hair short, and if they were especially fortunate, they could choose their own partners.

The new role of the working woman changed how women were viewed in general and inspired new needs, wishes and looks. The artist Alexander Alexandrovich Deineka celebrated this new image in a euphemistic and slightly utopian portrait of rosy-cheeked, bare-foot and lightly dressed female textile workers effortlessly going about their heavy, dangerous work in brightly lit factory halls.

Equality and the new woman were only just starting to gain traction in the real world, however. One of the modern Bauhaus female icons was Margarete Heymann-Marks. Donning trousers, a shirt, tie and a short-cut hairdo, she openly demonstrated her emancipation. After her application to join the ceramics workshop was turned down at the Bauhaus, she protested, and aggressively so,

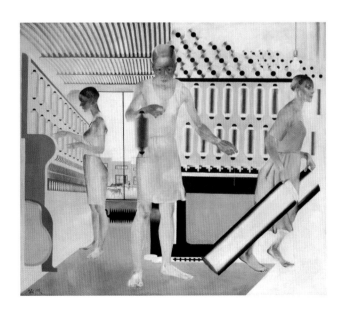

Alexander
Alexandrowitsch
Deineka, *Textil-
arbeiterinnen*
(*Textile Workers*),
1927

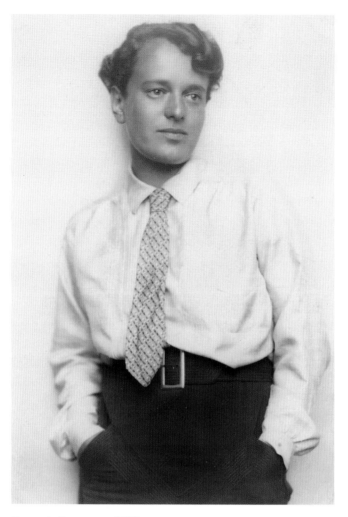

Margarete Heymann, c.1925

demolishing a workshop room in Dornburg in anger at what she claimed was an unjustified decision. Nonetheless, she became an extremely successful ceramics artist and founded the Haël-Werkstätten für künstlerische Keramik (Haël Workshops for Artistic Ceramics). After being pressured to relinquish ownership of part of her company, the National Socialists eventually forced her to sell the entire enterprise. The company was Aryanised, and Hedwig Bollhagen took over operations. Because of her Jewish background, Margarete Heymann-Marks was forced to emigrate to England.

DER MENSCH
DAS MASS ALLER DINGE

Geometrische Teilung einer
Länge s nach dem Goldenen
Schnitt

Ernst Neufert, 'Der Mensch, als Mass und Ziel' ('The Human, the Measure of All Things'), in *Bauentwurfslehre* (*Architectural Design Theory*), 1936

Speed, information and trust in the relevance of scientific knowledge were the explanatory principles for society between the world wars. Studies on spatial needs and ergonomics resulted in more effective designs of everyday tasks, buildings and objects. Standardisation was a guarantee for the logical coherence of design. There was no question that it had a positive effect on the constructed and designed world for everyone. Yet when taken to the extreme, standardisation resulted in marginalisation. It provided a seemingly science-based justification for racism, eugenics and euthanasia. Consequently, at the infamous Lebensborn homes, women only bore children who corresponded to the norms of the inhumane Aryan racial policies of the National Socialist regime. The aim was to breed and raise a generation of Aryan elite. In some cases, children from Czechoslovakia, for example, were kidnapped and placed in German families to be raised as Aryans. Collectivised norms not only resulted in the suppression of individuality, but also dangerous marginalisation as these norms became Nazi ideology. UTE ACKERMANN

THE SPIRIT OF THE BAUHAUS IS THE EXPERIMENT

The provisional, experimental and open

Nikolai Wassiljew,
Material study,
preliminary course
by Johannes Itten,
c.1920 (photography)

THE WEIMAR BAUHAUS was a living academic experiment. In its search for new forms of artistic education, it rejected the art-academy system, expanded traditional artistic horizons and tested unconventional teaching methods. With respect to the Bauhaus, the idea of experimentation has always been equated with its visionary beginnings and its commitment to an open-minded attitude towards teaching. Critics of the Bauhaus, however, sought to discredit the school by portraying its eagerness to experiment as a hapless, senseless method of trial and error.

The 'Bauhaus experiment' took the social promise of the young German democracy at its word; its programme was developed in an atmosphere of intensive discussion on the social relevance of the fine arts and architecture, as well as its potential to exert political influence. The basic premise was that good design should meet the demands of modern life and be accessible to all. Many believed the Bauhaus could serve to build the democratic society of the future. The school's failure to withstand the political headwinds in Weimar made the volatility of this historical experiment all the more tangible.

The Bauhaus preserved its general openness throughout its years in Weimar, which in turn enabled it to correct mistakes and institute changes as needed. Each new appointment to the teaching staff introduced students to new methods and teaching concepts. Thanks to the dynamic character of the Bauhaus programme, these changes did not destroy the school, but rather enhanced its reputation further.

Neither the Manifesto nor the programme of the Staatliches Bauhaus in Weimar of 1919 prescribed any fixed methodology. Everything was based on development and change. Gropius did not

adopt the academic and artisanal methods of reproduction taught by predecessor institutions. The Bauhaus project was fully committed to a utopian future. With its plans to develop 'comprehensive utopian architectural designs – secular and sacred buildings', the Bauhaus community had set ambitious goals for itself. The hope was that these goals would once and for all surmount the 'class distinctions that raise an arrogant barrier between craftsman and artist'. The Bauhaus pursued the goal of building a society based on equality and solidarity on a smaller scale.

The Bauhaus viewed project work as an open-ended learning process which, in the best-case scenario, resulted in a successful design. But it could also end in failure, which the Bauhaus accepted as an essential element of the creative process. Students experienced artistic accidents and surprises with all their senses during the learning process irrespective of any anticipated concrete result. The economic professionalisation of the workshops and the introduction of serial production simultaneously evoked new calls for more freedom to experiment in the form of testing workshops or a building test site where students could freely investigate experimental design methods.

Experimentation possessed great potential which was especially visible in the student projects produced in the weaving workshop. Here, the virtues of solid craftsmanship came in direct contact with the Bauhaus penchant for experimentation. In 1920 the Bauhaus took the bold step of building the Haus Sommerfeld, which depended on broad-based collaboration among the Bauhaus workshops. This project put the equality of women and men at the Bauhaus to the test and developed a certain degree of volatility.

The Bauhaus continued to advocate the preliminary, experimental and open-ended character of the design process even after the pragmatic aspects of production had replaced the pathos-infused visionary ideals of the Bauhaus in its early years. UTE ACKERMANN

The institution

The Weimar Bauhaus was created in April 1919 by merging the former Grossherzoglich Sächsische Kunstgewerbeschule Weimar (Grand Ducal Saxon School of Art and Crafts) with the Grossherzoglich Sächsische Hochschule für bildende Kunst (Grand Ducal Saxon College of Fine Arts). And with that, the spirit of a new age entered the buildings of the predecessor schools designed by Henry van de Velde.

The programme of the Bauhaus embraced the premise that art itself is not teachable and is bound to emerge irrespective of any method. Both the fine and applied arts were thus subject to the same rules of design and required skills in craftsmanship. Teachers could impart knowledge and competence in the handicrafts, but art arose in the 'grace of a moment'. The artists and architects had to find their way back to their common origin, their craft. For this reason, all students were expected to take up training in a handicraft, which is why they were called 'apprentices' and 'journeymen'. The instructors were no longer referred to as professors, but rather 'Bauhaus masters'. The artists managed the workshops as either Form-Meister

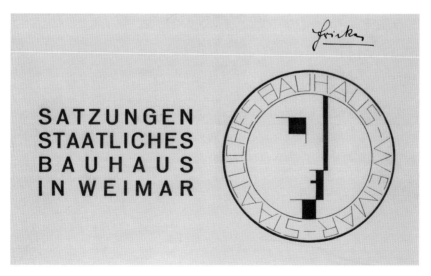

Oskar Schlemmer, Cover page of the Bauhaus statutes, Staatliches Bauhaus Weimar, 1922

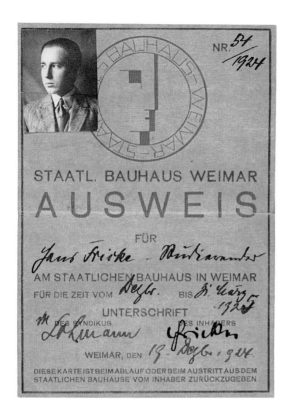

Staatliches Bauhaus
Weimar student ID card
for Hans Fricke, 1925

(masters of form) or Werk-Meister (masters of crafts). The Form-Meister conveyed their views and philosophies in the class 'Design Theory in Colour and Form' and in the preliminary course. Gropius hoped that one day the school would produce instructors who would be masters of both form and craft.

In the very beginning, some of the former professors of the Hochschule für bildende Kunst were appointed to teach at the Bauhaus. This led to internal conflicts, because the Bauhaus did not offer instruction in the fine arts as such, and the traditional painting and drawing classes were no longer included in the curriculum. Art was not the goal of the Bauhaus programme, but rather participation in the 'great building', which was meant in a literal sense, but also symbolically for the enormous collaborative project of shaping the future.

Those who wished to enrol at the Bauhaus were required to submit a portfolio of their works, a curriculum vitae and a police

clearance certificate. Based on these works, the Meisterrat (Masters' Council) selected candidates for admission on a probational basis.

The members of the Meisterrat were instructors of the Bauhaus. This committee was responsible for making important decisions, discussing programmatic changes, passing statutes and approving the appointment of new masters. The Meisterrat selected candidates for admission and subsequently evaluated their progress. It was also responsible for granting scholarships and assigning studios. However, only Form-Meister were permitted to sit on the committee and cast votes. For certain decisions, the committee sought the advice of the Werk-Meister and occasionally the journeymen and student representatives. The Werk-Meister were finally allowed to join the committee in 1923, when it was renamed the Bauhausrat (Bauhaus Council). UTE ACKERMANN

'The school is the servant of the workshop and will one day be absorbed in it'

The workshop activities formed the backbone of the Bauhaus. This is where students learned and practised basic techniques and handicrafts. Some of the former instructors of the Grossherzoglich Sächsische Kunstgewerbeschule Weimar were hired to head the workshops. This is how Helene Börner, who had managed the textile workshop at the Kunstgewerbeschule under Henry van de Velde, came to resume her activities at the Bauhaus. Otto Dorfner, who operated his bookbinding workshop at the school until 1922, is likewise associated with the Bauhaus.

Students at the Bauhaus were required to complete training in the handicrafts, for which there were ten workshops to choose from. However, the prospective apprentices were not guaranteed admission to a workshop; they had to earn it by successfully passing the preliminary course. Only then did the Meisterrat decide whether they should be allowed to begin an apprenticeship in a handicraft on probation. Candidates who proved their merit were then officially inducted into the workshop and received an apprenticeship contract.

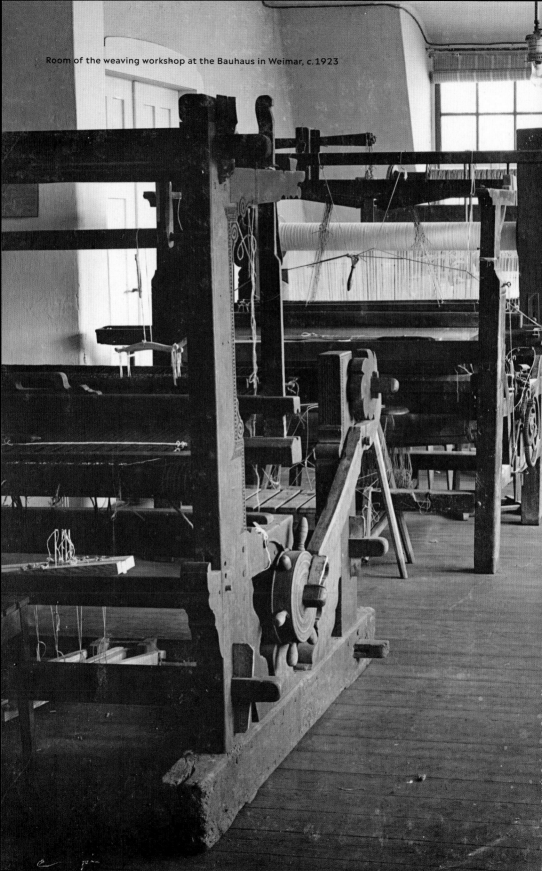

Room of the weaving workshop at the Bauhaus in Weimar, c.1923

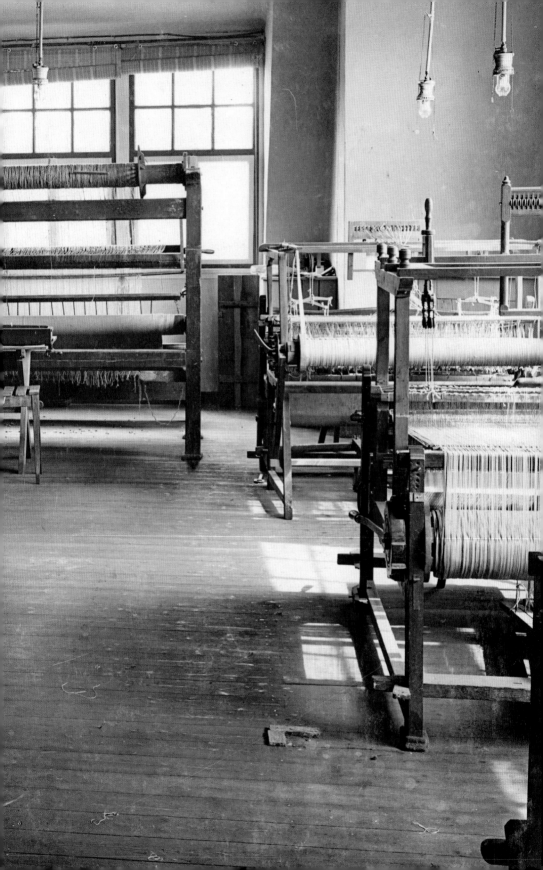

Although the contract was required by the programme, the rule was never fully implemented. The equal treatment of women and men also failed in practice in the workshop environment. Apart from the textile workshop, the doors to the other workshops were all but barred to women.

Because the budget of the Bauhaus strongly relied on the political circumstances in the State of Thuringia, Gropius tried to make the Bauhaus more financially independent by requiring the workshops to emphasise production. The aim was to manufacture Bauhaus products in series and market them. For example, the syllabus of the graphic printing workshop in 1922 stated that it was to operate essentially as a production workshop. The apprentices would continue to learn the techniques of the art printing craft but would no longer conclude their training with the prescribed statutory certificate of apprenticeship. Because the graphic printing workshop was no longer bound to work exclusively for members of

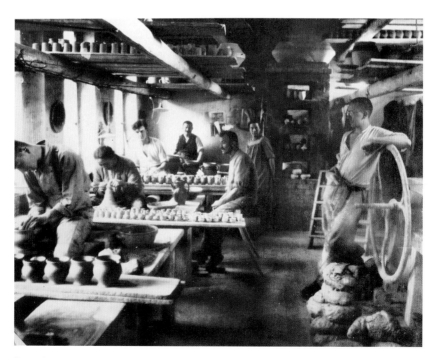

Ceramics workshop, Staatliches Bauhaus Weimar, Dornburg, c.1924

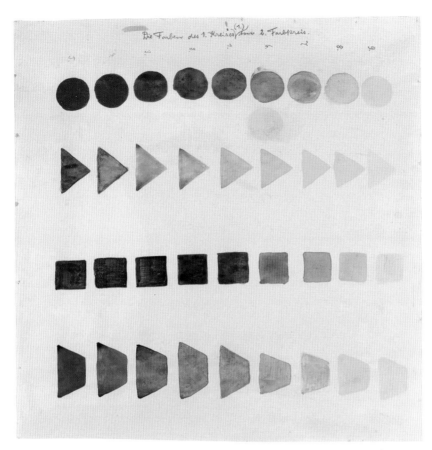

Ilse Bettenheim-Hoernecke, *Die Farben des 1. Kreises im 2. Farbkreis in neun Stufen* (*The Colours of the 1st Circle in the 2nd Colour Circle in Nine Steps*), harmonisation theory by Gertrud Grunow, 1924

the Bauhaus, it was able to quickly establish itself as a self-sufficient workshop with a stable order situation. In addition to graphic prints, it began producing a large number of print materials after 1923. UTE ACKERMANN

The artist is a craftsman in the original sense of the word

The Bauhaus doctrine was largely influenced by the personalities of the Bauhaus masters, their artistic views and pedagogical ambitions,

Walter Köppe, Study: pictorial design theory by Paul Klee:
II.9 Circle-Square-Triangle design, 1927–28

and was characterised by the development of individual concepts
and creative freedom.

The Form-Meister at the Bauhaus were not employed to be
artists, but rather instructors. Many of them were confronted for
the first time with the task of communicating their views on artistic
theory and practice. This turned out to be conducive to promoting
open-mindedness towards other artistic views. The quality of the

Staatliches Bauhaus, Weimar.

Spezialität (Beruf): *Schlosser*

Geschlecht: *Män.*

Nationalität: *Polu. Jüd. abst.*

Die 3 aufgezeichneten Formen sind mit 3 Farben aus-
zufüllen - gelb, rot u. blau und zwar so, daß eine Form
von einer Farbe vollständig ausgefüllt wird:

Wenn möglich ist eine Begründung dieser Verteilung
beizufügen.

Begründung: *Blau scheint konzent-
risch zu sein. Rot bleibt auf
die Fläche liegen. Also bleibt
nichts anderes übrig als „das
Gelb in Dreieck reinzuzwängen.
Obwohl der Kreis für das Gelb
ebenso gut sein kann. Aber nicht
der Dreieck für das Blau weil
sonst die Form gebrochen wird durch die
Konzentrik*

Wassily Kandinsky and Max Krajewski, Questionnaire 1923-24

instruction derived from the mutual consideration of varying artistic concepts.

Johannes Itten, however, possessed extensive teaching experience and a unique concept which he taught to his students in the preliminary course. He wrote: 'I reduce all creative activity to its roots, to playing. Anyone who fails in this, I reject as an artist, as a student.'

His methods were based on perceiving contrasts, colours, shapes and materials with all of one's senses. No student could escape Itten's influence. Until 1922 he headed all the workshops, and attendance to his courses was mandatory. When he left the Bauhaus, László Moholy-Nagy took over the preliminary course. Dressed in overalls, the Hungarian Constructivist resembled an engineer and perfectly embodied the new motto of the Bauhaus, 'Art and Technology – A New Unity'. In his lessons he concentrated on teaching students to sensually explore materials, balance and space. Along with Itten and Moholy-Nagy, Gertrud Grunow also advocated a holistic approach with her harmonisation theory.

Wassily Kandinsky and Paul Klee regularly taught courses in 'Design Theory in Colour and Form'. Students were introduced to their personal artistic principles, which, though related to the fine and visual arts, served as the general basis for all artistic activity and offered various approaches to working on design.

Kandinsky started with concrete objects and used analytical drawing to simplify them into abstract depictions. He investigated the essence and effect of colours and classified them according to form. Paul Klee, on the other hand, used nature studies to explore the essence of the world beyond its visible surface. On the basis of his design theory, he investigated how pictorial elements were created.

Lyonel Feininger and Gerhard Marcks did not offer any systematic instruction at the Bauhaus. Rather, they worked closely with their students in the graphic printing workshop and the ceramics workshop, where students directly benefitted from their expertise and influence. UTE ACKERMANN

Margit Téry-Adler, *Naturstudie Silberdisteln* (*Silver Thistle*, nature study),
preliminary course by Johannes Itten, *c.*1920

Walter Determann, Concept for a Bauhaus Settlement in Weimar, site map, 1919–20

Our game – our party – our work

Walter Gropius envisioned the Bauhaus to be much more than just a school. He wanted to establish a community that sprang from a unified spirit of the day and strived to shape life accordingly. To achieve this, collaboration among like-minded individuals was required, free of the arrogant differentiation between artists and craftspeople. His was nothing less than a joint project to develop new utopias for modern-day society, which the Bauhaus would create and propagate to all of society.

In line with Gropius's vision, Walter Determann and several other students founded a working group in 1919 devoted to planning their own Bauhaus settlement. They designed houses and furniture and considered possible community buildings and their respective facilities. The plan proposed constructing an enclosed settlement which symbolised the seclusion of the Bauhaus community with respect to the rest of society.

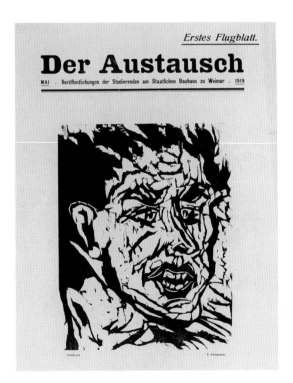

Eberhard Schrammen, woodcut for *Der Austausch* (*The Exchange*), publications by students of the Staatliches Bauhaus Weimar, May 1919

The students of the Bauhaus elected a student government called the 'Free Association'. This body organised regular parties and excursions for the Bauhäusler and in summer 1919 published its own journal, *Der Austausch* (*The Exchange*). The magazine served as a forum to freely discuss controversial issues related to art, architecture, theatre and literature. In the beginning, former university graduates who were pursuing further study at the Bauhaus played a leading role in the interscholastic dialogue. They were joined by another close-knit group of students in autumn 1919 who had studied under Johannes Itten in Vienna.

The Bauhäusler threw parties that were boisterous, colourful and characterised by unconventional clothing and hairstyles. With such displays of oftentimes unusual behaviour, they demonstrated how different they were from the inhabitants of small-town Weimar.

Even before regular instruction began at the Bauhaus, Gropius ensured that a cafeteria was installed. As it was the only room regularly heated, it gradually became the central meeting place for the Bauhaus community. It offered the student body and teaching staff the chance to eat affordable meals in a convivial atmosphere. In the Bauhaus garden on the parcel of land 'Am Horn', students planted vegetables which were then prepared in the cafeteria according to a special dietary regimen devised by Johannes Itten. Everyone pulled together to mitigate the dire circumstances and privation of the postwar years.

And although the utopian vision of the Bauhaus settlement never left the drawing board, the vibrant Bauhaus community certainly became a reality. UTE ACKERMANN

'What remains is the metaphysical – the art'

Oskar Schlemmer noted this philosophical thought in his diary in November 1922. Most Form-Meister in the workshops at the Weimar Bauhaus were painters: Lyonel Feininger, Johannes Itten, Paul Klee, Wassily Kandinsky and Oskar Schlemmer. Walter Gropius had become acquainted with some of them during his time at the

Oskar Schlemmer, from the portfolio *Spiel mit Köpfen* (*Play on Heads*), c.1920, printing workshop of the Staatliches Bauhaus Weimar, loan from the Bauhaus. Weimar.Moderne. Die Kunstfreunde e. V.

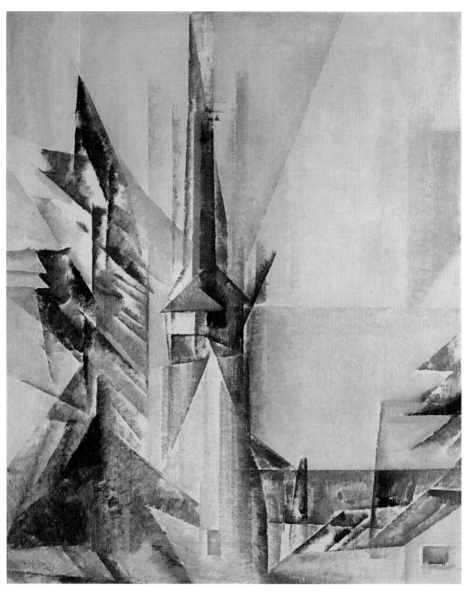

Lyonel Feininger, *Gelmeroda XI*, 1928, purchase made possible by the Federal Republic of Germany, Free State of Thuringia, Hermann Reemtsma Stiftung, Ernst von Siemens Kunststiftung, Cultural Foundation of German States

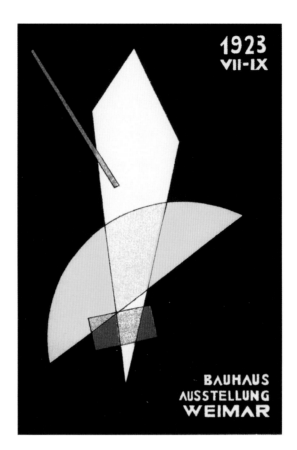

László Moholy-Nagy,
Postcard for the 1923
Bauhaus-Ausstellung 1923,
no. 7, 1923

Berlin avant-garde gallery Der Sturm and hoped they would provide important impulses for his reform project, for example, innovations in teaching and artistic inspiration for practical design. However, the academic requirements of the school often conflicted with their personal standards as artists. Several artists were critical of how the Bauhaus was developing, especially following the appointment of László Moholy-Nagy in 1923. Moholy-Nagy was a proponent of a decidedly constructivist school of art. He did not see himself as a traditional painter beholden to the primacy of painting but rather as an 'engineer-artist' who experimented with new media, with lighting, photography and film.

The Weimar Bauhaus did not offer painting as a subject, but due to high demand, the Bauhaus Dessau began offering the subject

Paul Klee, *Wasserpark im Herbst* (*Water Park in the Autumn*), 1926, purchase made possible by the Cultural Foundation of German States, the Federal Commissioner for Culture and Media Affairs, Thuringian Ministry for Science, Research and Art, Ernst von Siemens Kunststiftung, Bauhaus.Weimar. Moderne. Die Kunstfreunde. e.V., Karl Peter Röhl Stiftung, City of Weimar, Sparkasse of the city of Weimar

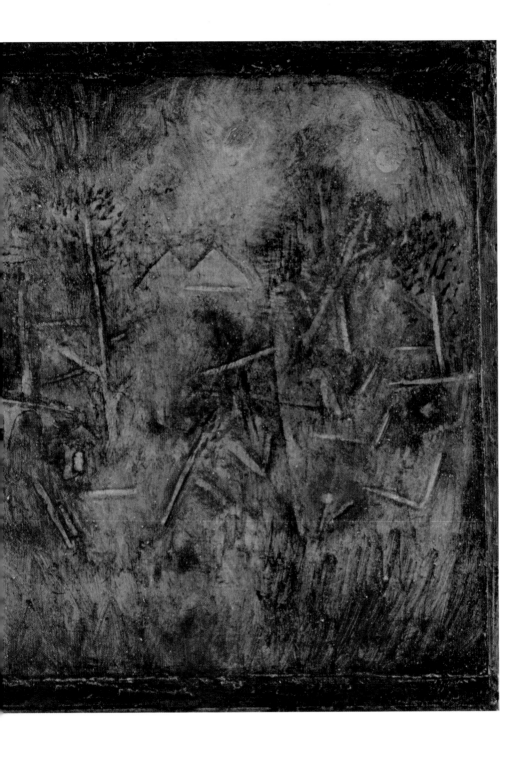

Max Peiffer Watenphul, *Friedhof in Weimar* (*Cemetery in Weimar*), 1921,
loan from a private collection

in 1927. The students recognised the appeal of free artistic endeavour; they painted in various styles and learned about the latest trends in the international art world. Many of them attended the *Erste russische Kunstausstellung* (*First Russian Art Exhibition*) in Berlin in 1922, which featured a comprehensive overview of the most recent trends in Russia. In 1922 Theo van Doesburg, who was an outspoken critic of the Bauhaus, offered a De Stijl course for young artists in Weimar. About twenty people attended the course in the studio of Karl Peter Röhl, who was a Bauhaus student himself. In December 1922 the journal *Út* published the 'KURI Manifesto', in which a group of Bauhaus students declared their support for Constructivism. This resulted in a fascinating panorama of painting and artistic styles at the Bauhaus from that period, ranging from

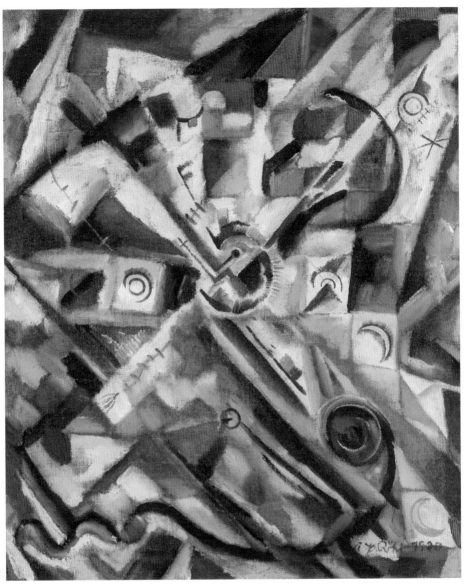

Karl Peter Röhl, *Ohne Titel* (*Kosmische Komposition II*) (*Untitled [Cosmic Composition II]*), 1920, loan from a private collection

Oskar Schlemmer, Wall decoration of the vestibule in the workshop building, 1923

late Expressionism to Futurism, from Constructivism and Object-ivism to Naturalism, Naïve and Surrealism.

The Weimar museum director Wilhelm Köhler proved to be quite open to these new trends. He purchased masterpieces by Paul Klee, Wassily Kandinsky and Lyonel Feininger and displayed the works by these Bauhaus masters in several rooms of the Stadtschloss (City Palace). However, the National Socialists brought this promising beginning to a screeching halt in 1930. Numerous works of modern art – not only those by the Bauhäusler – were removed and put into storage until they were confiscated in 1937 as part of the Nazi campaign against 'Degenerate Art'. The National Socialists had already carried out an iconoclastic foray of sorts in October 1930 when they destroyed Oskar Schlemmer's wall decorations in the workshop building that he had created for the *Bauhaus-Ausstellung* (*Bauhaus Exhibition*) of 1923. This attack was not only directed at what the Nazis considered undesirable art, but also its inherent notion of freedom, liberalism and individual subjectivity. ULRIKE BESTGEN

Walter Gropius founded a new school with a radical programme

Walter Gropius, Bauhaus director from 1919 to 1925 in Weimar and until 1928 in Dessau, had the hardest job of all. At a time of sweeping political change and unimaginable economic hardship, he founded a new school of an entirely different cast. Trained as an architect, Gropius served in the First World War. Henry van de Velde, director of the illustrious Grossherzoglich Sächsische Kunstgewerbeschule Weimar, founded in 1908, recommended Gropius as his successor in 1915 just months before the school closed. Even the painter Fritz Mackensen, who was serving as the director of the Grossherzoglich Sächsische Hochschule für bildende Kunst at the time, had a high opinion of Gropius. In their correspondence, they often discussed establishing a school of architecture in Weimar.

By 1916 Gropius had drafted numerous proposals 'from the field' for reforming the school in Weimar, which he conceived as an 'artistic consultation office for industry, the trades and crafts'. After Fritz Mackensen resigned his post in summer 1918, and after the Armistice, the November Revolution and the abdication of the last Grand Duke Wilhelm Ernst of Saxe-Weimar-Eisenach, Gropius re-iterated his wishes and entered negotiations with the state author-ities. On 1 April 1919 he assumed management of the Grossherzoglich Sächsische Hochschule für bildende Kunst, which he then symbol-ically merged with the no longer existent Grossherzoglich Sächsische Kunstgewerbeschule Weimar. With the approval of the state regu-latory body, he named the new institution the Staatliches Bauhaus Weimar (Weimar State Bauhaus).

In May 1919 Gropius published his radical ideas for reforming the art school in the Bauhaus Manifesto and the programme of the Staatliches Bauhaus Weimar. Their content was influenced, among other things, by the Berlin-based social-revolutionary Arbeitsrat für Kunst (Work Council for the Arts), which Gropius joined at the end of 1918 and headed in February 1919. Its primary goal was to pursue a strictly anti-academic reform programme and reunite the artistic disciplines of sculpting, painting, arts and crafts and the

trades under the supervision of architecture. He likened the concentrated working community of instructors and students to a medieval builders' hut adapted to the demands of the times.

Gropius had to overcome enormous challenges in building his new school. Internally, politically minded students on the left and right made his life difficult. Right-wing conservatives lodged complaints with the state government, whilst nationalists published inflammatory diatribes such as the 'Yellow Brochure'. Craftsmen feared competition from the school. Gropius tried to shield the Bauhaus from outside turbulence and even issued an edict on 18 December 1919 forbidding students from expressing their political opinions on school premises – a highly problematic decision and evidence of the school's ambivalence towards inner-school democracy. ULRIKE BESTGEN

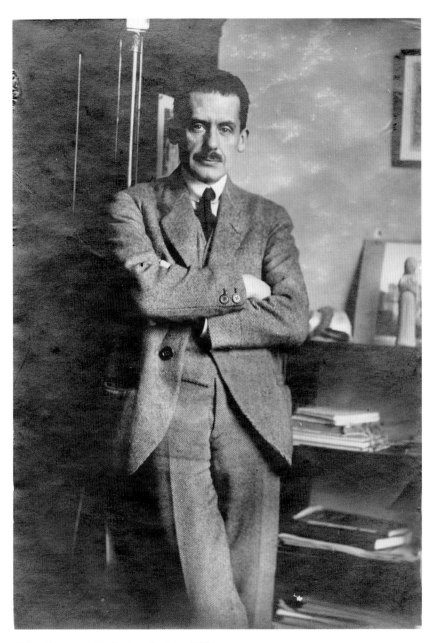

Walter Gropius at the Weimar Bauhaus, 1921

THE STAGE

The school's centre of creativity

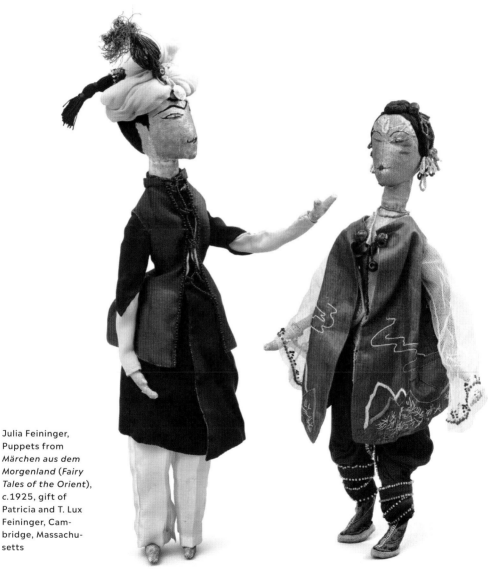

Julia Feininger, Puppets from *Märchen aus dem Morgenland* (*Fairy Tales of the Orient*), c.1925, gift of Patricia and T. Lux Feininger, Cambridge, Massachusetts

'**WE INVESTIGATE** the individual problems of space, the body, movement, form, light, colour and sound. We create the movement of the organic and the mechanical body, vocal intonation and musical sound and build the theatre space and the theatre figures. The conscious application of the laws of mechanics, optics and acoustics is key to our stage design.' With this portrayal of the activities of the theatre workshop, Walter Gropius presented an ambitious programme in October 1922. The aim was to explore the problems of the stage in terms of their theoretical and practical impact, unfettered by the constraints of commercial theatre. He was not interested in offering one-dimensional solutions but rather in presenting a diverse spectrum of ideas as we are accustomed to today. 'For we want to move beyond the one-sidedness of the usual approaches in order to master the sublime problems of theatre in many ways.'

In declaring his commitment to creative, design-orientated diversity, Gropius laid the cornerstone for the unique character of the theatre workshop in Weimar, which became a kind of 'theatre laboratory'. The famous *The Theatre of the Bauhaus*, published as the fourth volume of the Bauhausbücher (Bauhaus Books), impressively reflects the function of the stage as an integrative forum of the school. The volume contains pioneering articles by such diverse artistic figures as Oskar Schlemmer and László Moholy-Nagy, whilst students documented their own sketches, plays and visionary set designs.

'Like an orchestral unit, the theatre piece is internally related to a work of architecture; both receive and give to each other reciprocally', wrote Gropius in the catalogue of the *Bauhaus-Ausstellung*

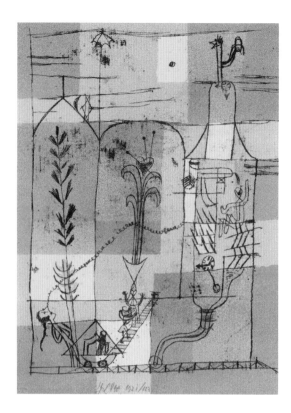

Paul Klee, *Hoffmanneske Szene* (*Hoffmannesque Scene*), 1921, from *Neue europäische Graphik, 1. Mappe: Meister des Staatlichen Bauhauses in Weimar* (*New European Graphics, First Portfolio: Masters of the Staatliches Bauhaus Weimar*), printing workshop of the Staatliches Bauhaus Weimar

of 1923. For Paul Klee, the stage represented the true centre of artistic education with the goal of allowing students to engage in individual creative design. Oskar Schlemmer shared a similar view of the function of the theatre, which he characterised in 1929 as the 'place of convergence for the metaphysical from the all too objective tendencies'. The stage, as he put it, was the 'flower in the buttonhole of the Bauhaus'.

The innovative, artistic-educational character of the Bauhaus theatre played an essential role in enhancing the reputation of the school. It was conceived as a kind of cross-sectional workshop which was open to all students and became a platform for a wide variety of creative approaches. The theatre operated as a special training area from 1921 to 1929. The expressionist painter and poet Lothar Schreyer served as its first director, followed by Oskar Schlemmer in 1923, who headed it until he left the Bauhaus. Between 1922 and

1924, Bauhaus students staged numerous theatre experiments based on what are still topical subjects today, for example, 'Man and Machine', or thematically focussed on the circus or vaudeville elements as a new form of theatre performance. When the Bauhaus was reorganised in Dessau, the aspect of free artistic experimentation fell to the wayside; the theatre workshop was professionalised and was given a room of its own in the Bauhaus building.

Especially in the early years of the Bauhaus, the sometimes overly exuberant creativity of the Bauhaus theatre was expressed in numerous ways. As was so often the case, Schlemmer was the one to shed some light on the creative process: 'Theatre at the Bauhaus was up and running from the first day forward, just like the urge to act was there from the first day. The urge to act, which Schiller in his still wonderful *Letters on the Aesthetic Education of Man* described as the force from which the truly creative values of man flow.' Schlemmer added that the joy of acting and the eagerness to create was especially evident in the 'childhood' of the Bauhaus, manifested in 'high-spirited parties, vivacious improvisations, in the design of fantastical masks and costumes'.

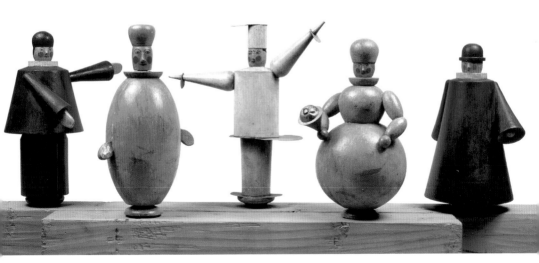

Eberhard Schrammen, Five hand puppets, c.1923, loan from
Theaterwissenschaftliche Sammlung der Universität Köln

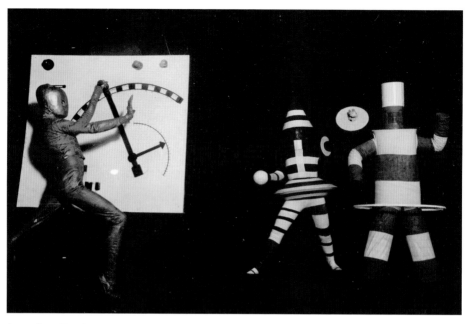

Scene from Kurt Schmidt's play *Der Mann am Schaltbrett* (*The Man at the Control Panel*)

Scene from Kurt
Schwerdtfeger's
*Reflektorische
Farblichtspiele*
(*Reflecting Colour-
Light Play*),
photo: Atelier
Hüttich & Oemler,
Weimar, 1923

The performance – and indirectly the precious assets of artistic freedom and autonomy – were not only the basis of theatrical work but also existential prerequisites for the training and teaching programmes of the early Bauhaus. Johannes Itten in particular was convinced that creativity and performance were effective means for countering the restrictive constraints of traditional academic art education. A short time later, Itten had a falling-out with Walter Gropius on fundamental issues pertaining to the direction Gropius was taking the school.

Parties and performances marked the fixed dates in the recurrent Bauhaus calendar each year: the dragon festivals in the autumn, the annual lantern festival on 21 June and Walter Gropius's birthday on 18 May. The preparation for the festivals required everyone's effort; the students and teaching staff all enthusiastically pitched in to help. Despite – or perhaps because of – the dire poverty of many students, these festivals were an occasion to demonstrate their *joie de vivre*.

The Bauhaus stage was not showered with unanimous praise, however. Sometimes distinguished experts voiced criticism, such as Thomas Mann, who after attending a theatre exhibition in 1927 was quoted: 'Don't forget to take a look at the Bauhaus stage, the poet's guillotine.' ULRIKE BESTGEN

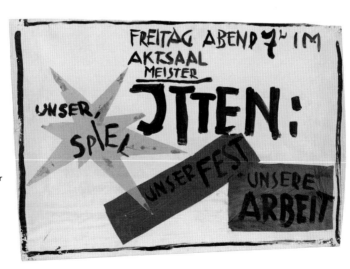

Rudolf Lutz, Poster design for 'Itten: Unser Spiel, unser Fest, unsere Arbeit' ('Itten: Our Game, Our Party, Our Work'), 1919

An Expressionistic Bauhaus stage?
Lothar Schreyer fails

Before his appointment to the Bauhaus, Lothar Schreyer, a lawyer by profession, headed the theatre at the Sturm in Berlin, followed by the Kampf-Bühne in Hamburg, which was a continuation of the Sturm theatre. From 1921 to 1923 he served as the director of the Bauhaus theatre workshop. His view of the Bauhaus stage differed fundamentally from that of Walter Gropius. While Gropius referred to the exploration of the formal artistic and spatial means of theatre, Schreyer emphasised its cultic, communal character, which he regarded as both the origin of theatre and a return to the 'birth of tragedy' à la Nietzsche. Schreyer held an expressionistic view of theatre, which presented mythical-religious plays rife with pathos. His figurines celebrated the 'New People' and are laden with symbolism and religious allusions. In terms of content, the theatre under Schreyer's direction made reference to profound issues of humanity, for example, birth, death, sin and the existential inevitability of fate. In contrast to contemporary theatre reform movements, the spoken word was very important to Schreyer. Using a prepared score called a *Spielgang* ('play walk'), he would meticulously note the exact sequence of sounds, words, noises and movements for the play.

At the Weimar Bauhaus, he directed the *Mondspiel* (*Moon Play*), which he planned to present during the Bauhaus Week in 1923. The play consisted of 346 verses with no dramatic plot, just purely phonetic poetry. It centred around Saint Mary in the Moon as a symbol of all-encompassing, healing love who receives the veneration of a dancer at her feet. Mary stood motionless while the dancer was concealed behind a shield which he gently raised and lowered. Long rehearsals were needed to practice what Schreyer called *Klangsprechen* ('sound speaking') in the correct rhythm and pace. Mary's mask, which measured about two metres in height, was based on the traditional depictions of Mary in a mandorla, while the dancer's shield featured an abstract colour composition with a moon eye at the centre.

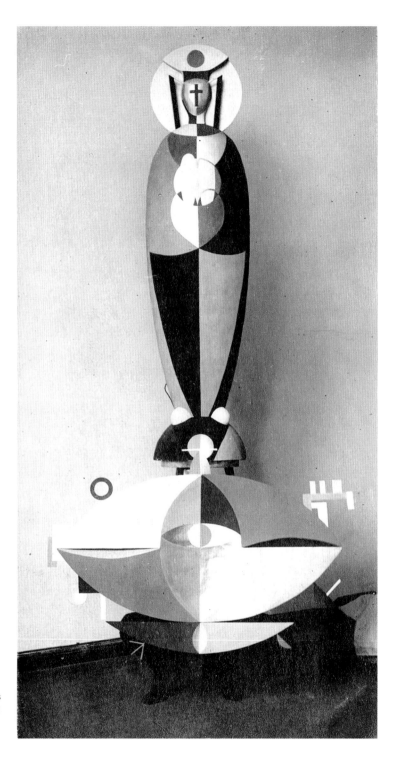

Rehearsal of
Lothar Schreyer's
Mondspiel (*Moon
Play*) at the
Bauhaus, 1922

Schreyer's expressive rigour was met with bewilderment at the Bauhaus. The students rejected Schreyer's theatre concept and the dress rehearsal of the *Mondspiel* on 17 February 1923 was an utter fiasco. Schreyer resigned as director of the Bauhaus stage shortly thereafter. ULRIKE BESTGEN

The Triadic Ballet

Strictly speaking, it wasn't produced at the Bauhaus, but Oskar Schlemmer's *Triadic Ballet* certainly exemplifies the visionary accomplishments of the Bauhaus stage like no other work.

Schlemmer started developing the concept for the piece in Stuttgart in 1912. Animated by his friendship with the dancers Albert Burger and Elsa Hötzel, he began to study dance and how it could be adapted to theatre. The world premiere of the *Triadic Ballet* took place in Stuttgart in 1922 – an event that Gropius and a group of fellow Bauhäusler had the fortune to experience.

By that time Schlemmer had already received an appointment at the Bauhaus in 1921. He first headed the workshop for mural painting, stone and wood sculpting and taught courses in nude and figurative drawing. The central theme of his artistic work was the human being, portrayed as a type, not as an individual, and executed in a modern style that always adhered to the classical principles of artistic design. After Lothar Schreyer's abrupt departure, Schlemmer took over the Bauhaus theatre, with which he achieved legendary success, especially in Dessau.

Based on the Greek term *triad* meaning 'comprised of three parts', Schlemmer developed the ballet according to this strict principle of order: three dancers performed twelve different dances in a total of eighteen costumes, either alone, in pairs, or in threes, spread across three levels in a yellow, pink and black sequence. For the performance in Weimar during the Bauhaus Week in 1923, Schlemmer likely changed the sequence for technical and organisational reasons, positioning the black sequence before the pink sequence. This decision naturally changed the intended heightening

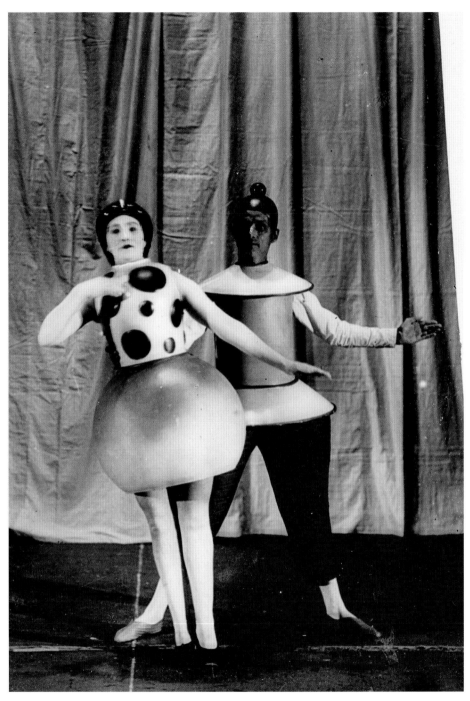

Two figurines from the 'Gelbe Reihe' ('Yellow Series'), scene from a performance of the *Triadisches Ballett* (*Triadic Ballet*) by Oskar Schlemmer in Weimar, 1923, photo: Continental Photo Berlin

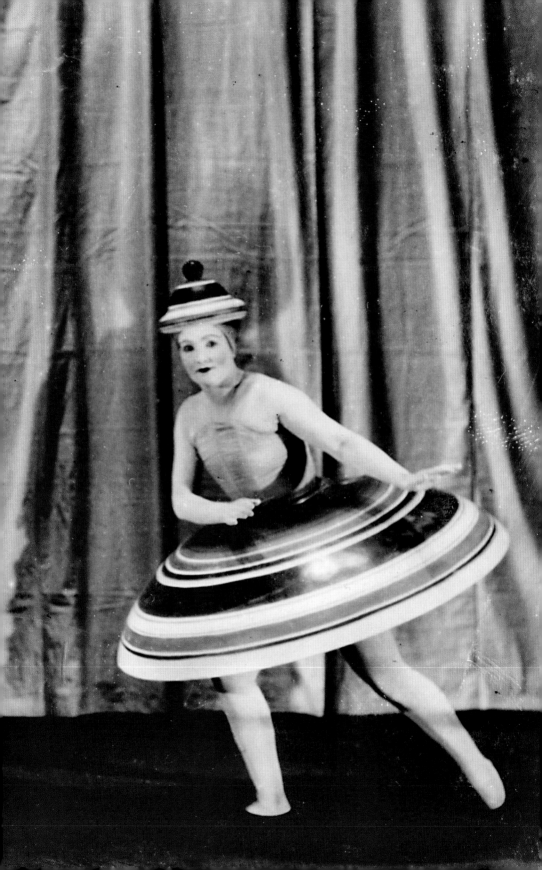

of the ballet from 'cheerful burlesque' to 'festive solemn' to 'mythical fantastic'.

Schlemmer viewed his ballet as belonging to a long literary, visual arts tradition starting with Heinrich von Kleist and E. T. A. Hoffmann and ending with Charlie Chaplin, all of whom addressed the theme of an artificial, mechanical figure. Schlemmer designed over-dimensional costumes for the ballet, some of which were quite voluminous. They were worn by the dancers and effectively served to demonstrate various coloured, metal sculptures. The choreography prescribed the sequence of steps, gestures and movements in detail, whereby the costumes, on account of their formal characteristics, decisively impacted the movements and influenced the physical feelings of the dancers.

The ballet was extensively reconstructed at the end of the 1960s; the most recent production from 2014 is still being performed by the Bavarian State Ballet. The *Triadic Ballet* has enjoyed enormous popularity among subsequent generations of visual artists and in pop culture of the late twentieth century. ULRIKE BESTGEN

The Mechanical Ballet: A highlight of student work for the Weimar Bauhaus stage

As part of the *Bauhaus-Ausstellung*, Kurt Schmidt staged a rousing performance of his *Mechanical Ballet* during the Bauhaus Week at the Stadttheater Jena on 17 August 1923. During the thirty-minute performance with music by Hans Heinz Stuckenschmidt, brightly coloured forms and shapes danced across the stage. The forms were attached around the front and back of the dancers, who were dressed in black leotards. The stage and background were also painted black to prevent the dancers' standing out. The participants on stage had to maintain the illusion of a two-dimensional proscenium, that is, they were only allowed to move parallel to the edge of the stage or behind one another but were not permitted to turn. Shifting back and forth between and behind one another, they constantly created new abstract forms and colour compositions on stage.

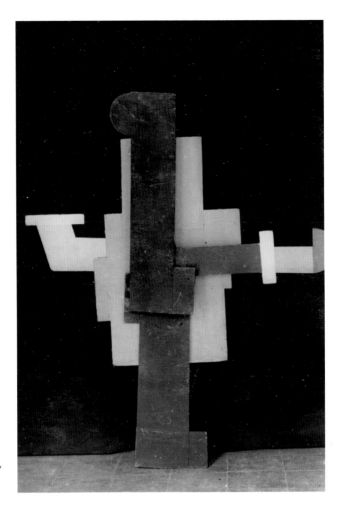

Scene from Kurt Schmidt's and Georg Teltscher's *Das mechanische Ballett* (*The Mechanical Ballet*), performance in Jena, 1923

The idea for the *Mechanical Ballet* originated from the Bauhaus student Kurt Schmidt, who constructed the figures with his classmates Georg Teltscher and Friedrich Wilhelm Bogler. The artistic intention, according to Schmidt, was to release the dynamic forces anchored in an abstract image and set them in motion using figural elements. Consequently, these elements, which were worn by the dancers and reinforced by hidden wooden slats, did not derive from the human body, but from constructive forms and surfaces. It was another example of the influence of the De Stijl movement from the Netherlands, which had developed similar

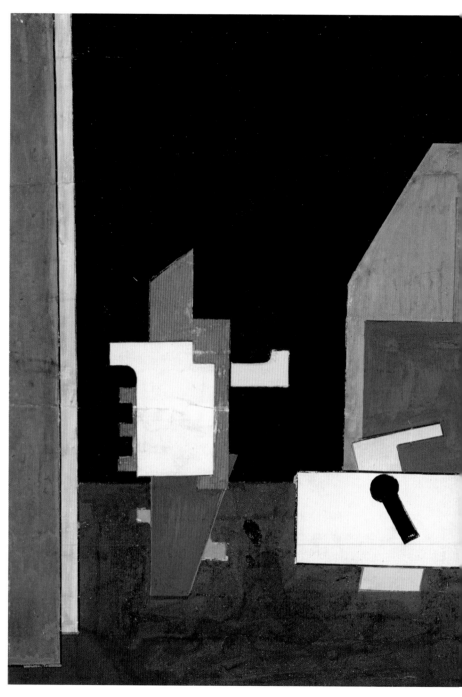

Kurt Schmidt, Design sketch for the *Das mechanische Ballett* (*The Mechanical Ballet*), 1923

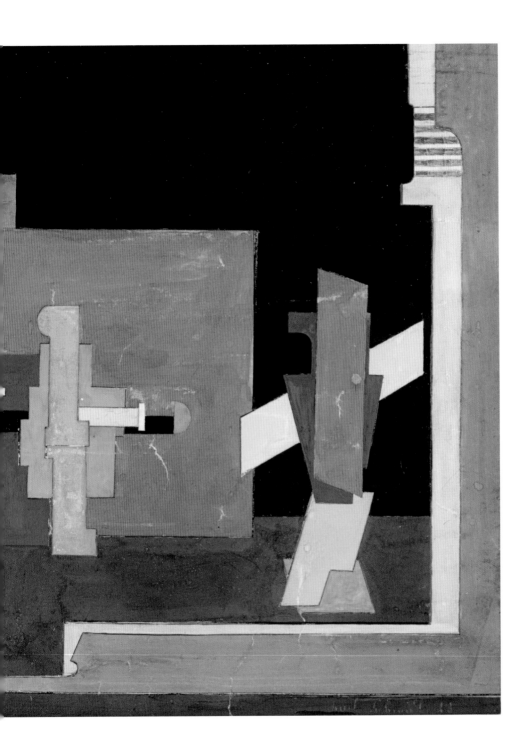

mechanical figures, as well as from the contemporary constructivist theatre in Russia.

In this charming performative Gesamtkunstwerk, the dancers moved to a jerky, mechanical choreography in rhythm with the music. In symbolising the modern industrial world and the demands of technology and machinery, Schmidt later explained that 'the *Mechanical Ballet* was an attempt to instil this technical character of our times with new possibilities of dance expression. If machines had enabled human beings to rule over the material world, then the *Mechanical Ballet* depicted the essence of machine beings and translated them into formative dance'. Yet he also instilled his machine beings with individual characteristics – for example, one can see a locomotive-like figure in the middle, a windmill and a miniature figure – and he animated them in what was occasionally humorous and comical stage action.

In 1987 the Theater der Klänge in Düsseldorf staged a new production of the *Mechanical Ballet* in close collaboration with Kurt Schmidt. ULRIKE BESTGEN

Never has there been more Bauhaus!
The Bauhaus celebrates festivals

According to former Bauhaus student Andor Weininger, the greater the hardship, the more important were the parties for the students. Weininger, a member of the famous Bauhaus orchestra, described these celebrations as an extremely important outlet for the young students. 'When everyone had worked hard, and there was depression and tension, some of us, the weather observers – the seismographs – would suggest that what everyone needed was a dance party.'

The first of these legendary Bauhaus parties was held in the Weimar restaurant Ilmschlösschen. The celebrations became an integral part of academic life and made an indelible mark on the memories of the Bauhäusler. Undeniably these parties contributed to the mythologisation of the Bauhaus.

An important part of these celebrations was the performance of the Bauhaus orchestra. In addition to Andor Weininger, its original formation included T. Lux Feininger, the son of Lyonel Feininger. The revels included sketches, improvisations, music by the Bauhaus orchestra, popular songs and, later in Dessau, jazz performances with rhythmic stomping, singing, whistling and lively dancing.

The group photo of students and teachers was taken during the party at the Ilmschlösschen on 29 November 1924 on the occasion of the fifth anniversary of the Bauhaus. Some of the participants are wearing costumes, such as Oskar Schlemmer at the centre of the photo donning a crown, while others are in normal street clothes. The signs with the words 'suspense', 'passion', 'catastrophe', 'exit' and 'intermission' had been used as props in the play *Meta, or the Pantomime of Places*, which had debuted in spring 1924. In this piece – a parody – five actors pantomimed the script and hung the signs on a ladder-like scaffold according to their place in the plot line.

It is no coincidence that these signs were included in this important, rather official Bauhaus group photo by the former court photographer Louis Held or one of his assistants at his studio. Shortly before it was taken, the political wrangling with the Bauhaus had come to a head; on 18 September the state government terminated the contracts of the Bauhaus director and the masters effective 21 March 1925 and, following a debate in the state parliamentary budgetary committee, the school's operating budget of 100,000 RM was cut in half to 50,000 RM. The continued existence of the Bauhaus in Weimar was in danger, if not rendered altogether unviable. The words on the signs can therefore be interpreted symbolically. ULRIKE BESTGEN

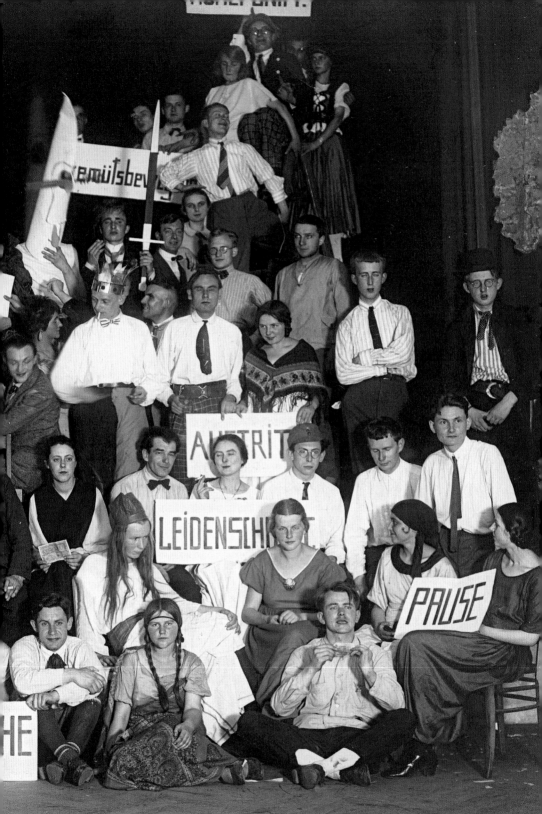

Bauhaus party at the Ilmschlösschen, photo: Louis Held, 1924

MODERN LIFE

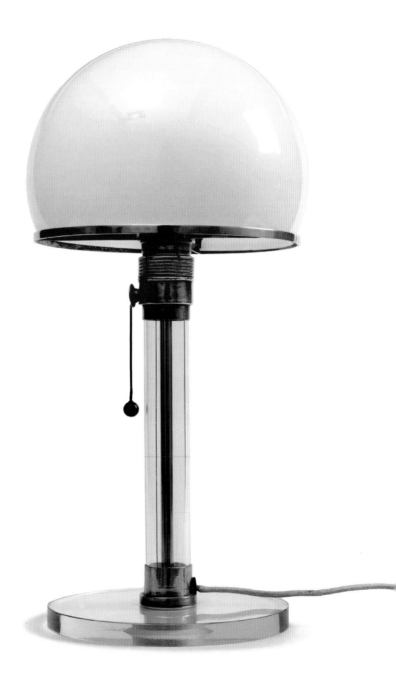

Wilhelm Wagenfeld
(design), Carl Jakob
Jucker (preliminary
work), Table lamp,
glass version MT 9,
1923–24

INDUSTRIALISATION IN THE NINETEENTH CENTURY set changes in motion that affected all areas of society and every social class. Cities were expanding, and the pace of everyday life was accelerating with new modes of transportation. Gas, running water and electricity found their way into private households. As scientific advances furthered the understanding of the world and affirmed the practically limitless power of human creativity, many were firm believers in progress.

The new technical possibilities and materials influenced architecture, the working world and everyday life in the Machine Age. They inspired new needs and sparked innovations and inventions which promised to make life easier. Mobility, hygiene, space optimisation, new lighting technology and energy sources in apartments resulted in changing tasks for designers. As the domestic staff of the upper-middle class sought better opportunities in factories, more and more households were forced to complete these services themselves. This resulted in an increasing demand for electrical appliances which could simplify household chores, for example, toasters, washing machines and vacuum cleaners.

For designers, it was difficult to develop products with models that not only met the requirements of industrial production but were also aesthetically pleasing. The hodgepodge of historical styles at the turn of the twentieth century and the massive dissemination of surrogates provoked calls for a 'reasonable' design. Reason became the all-encompassing catchword in new design theories. The establishment of the Deutscher Werkbund (German Association of Craftsmen) institutionalised the movement which aimed to educate the public by means of exhibitions and publications.

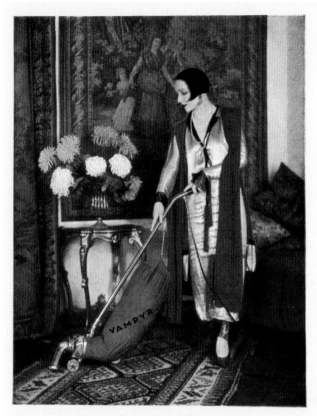

Edmonde Guy mit dem **AEG** Vampyr

Advertising post-card for the AEG vacuum cleaner Vampyr, featuring actress Edmonde Guy, 1925

Product functionality and growing technical possibilities presented a challenge to both designers and engineers. The advances in technical development manifested themselves in visible functional design with aesthetic assertiveness. The trend towards simplicity was paired with a demand for material-relevant design solutions for machine-based manufacturing. These designs were to be no longer based on historical forms, but genuinely correspond with their technical character. And the Bauhaus was wholly committed to this idea.

The students in the ceramics workshop, for example, studied traditional, handcrafted pieces with respect to their function and suitability for serial production. Craftspeople in the nineteenth

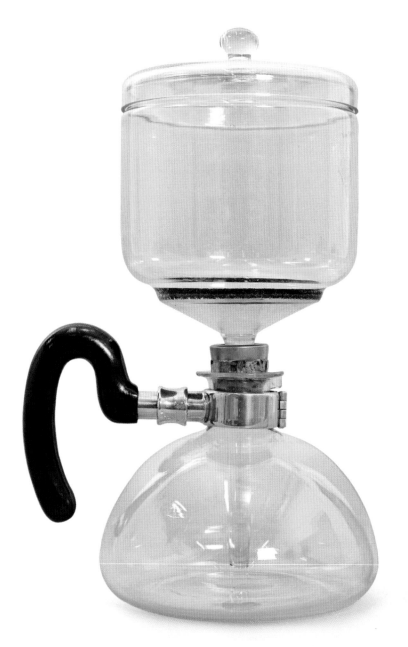

Gerhard Marcks, Sintrax coffee machine, Jenaer Glaswerk Schott & Gen., 1926, loan from Klaus Blechschmidt, Gotha

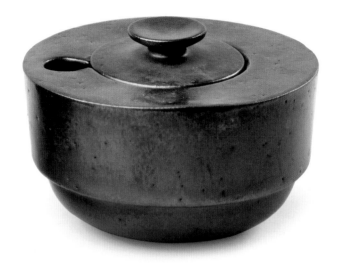

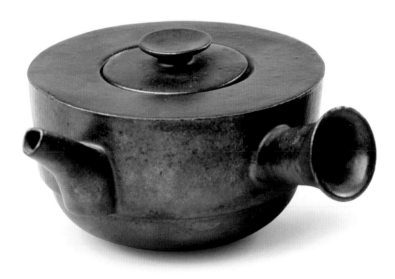

Theodor Bogler, sugar bowl L3 and infusion pot L2, 1923

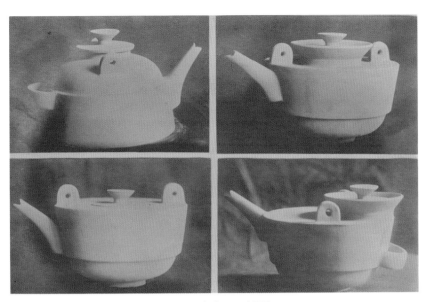

Theodor Bogler, combination teapot ceramic forms, 1923

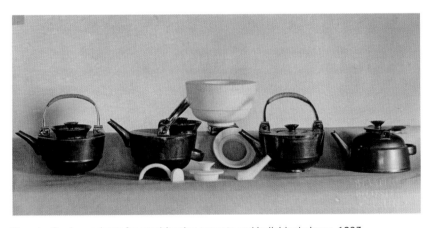

Theodor Bogler, variants for combination teapots and individual pieces, 1923

century had already started emphasising these aspects and designing them accordingly. Although the idea didn't originate at the Bauhaus, the focus on function and serial manufacturing was a central prerogative.

The insistence on specialisation with regard to function occasionally resulted in the creation of luxury products. By designing

Gyula Pap, seven-armed candelabra MT 2, 1922, purchased by the Sparkassen-Kulturstiftung Hessen-Thüringen with support from Bauhaus.Weimar.Moderne. Die Kunstfreunde e. V.

forms optimised for one purpose only, designers found it necessary to create other specialised objects. With their reduced forms of machine aesthetics and gleaming surfaces, such pieces were both functional and high-quality but were far from suitable for modern serial production. Most of these were individually produced by hand with exquisite materials and at exorbitant cost. Consequently, they are regarded as luxury goods, many of which have since become design icons.

The Jena-based glass manufacturer Schott & Gen., which had originally produced technical glassware, chose a different path. The

simple forms of cooking and baking utensils made of refractory glass were based on the functional requirements of the materials themselves. The company frequently applied the same techniques they had developed in their chemical laboratory. Translucent and easy-to-clean bowls and dishware may have removed the mystique of baking and cooking, but it also gave the kitchen a laboratory character and made working there more effective.

The changing working world required more individual flexibility and mobility. This meant that people could no longer count on remaining in one place all their life; often they had to move and change flats. Modern life meant that people needed to 'travel lightly', that is, there was a new demand for modular furniture and practical, space-saving items of daily life. Multifunctionality and stackability were, and still are, two strategies for solving these problems. Especially in the age of digitalisation, the optimisation of everyday life unattached to any specific place remains a relevant issue today and continues to confront designers with new challenges that far exceed product design. UTE ACKERMANN

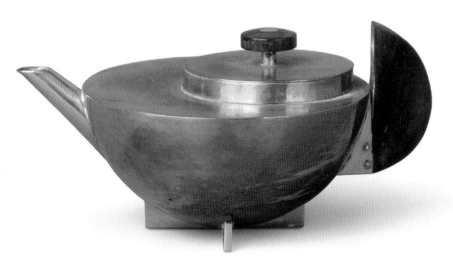

Marianne Brandt, Tea extraction pot MT 49, 1924

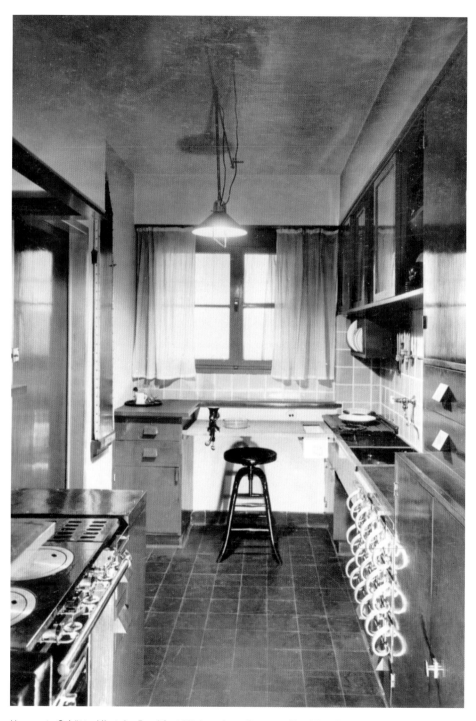

Margarete Schütte-Lihotzky, Frankfurt kitchen, from *Das neue Frankfurt* 5, 1926–27

Everything in reach: The kitchen

At the start of the twentieth century designers in Germany began devising ways to make kitchen chores easier. Some important impulses were provided by American and British women who had been experimenting with innovative, functional kitchen organisation. This trend was driven by the possibility of integrating modern industrial working methods into the private sphere. There was also a growing desire among the middle class to curb its reliance on servants for financial and legal reasons.

The German translation of *Household Engineering* by American author Christine Frederick was published in 1921. One can assume that this work influenced the first prototype of a fitted kitchen in Germany, namely, the kitchenette installed in the Haus Am Horn, designed by Benita Otte and constructed by Ernst Gebhardt. For the first time, kitchen furniture and appliances were arranged according to their respective working processes. The housewife could stow her purchases in the pantry, wash dishes in the washing basin, prepare and cook meals and serve them to her family in a separate dining room, step by step and without unnecessary paths. The space-saving work area replaced the large eat-in kitchens which were customary at the time. However, its design did not anticipate that the man of the house would play any part in the kitchen work.

After 1926 the architect Margarete Schütte-Lihotzky improved the design further, which eventually became known as the 'Frankfurt kitchen'. This version was installed as a standard feature in all the apartments of the Frankfurt housing programme headed by Ernst May. For this design, Schütte-Lihotzky created, among other features, a cupboard equipped with aluminium drawers for storing ingredients. In the Haus Am Horn, various ingredients were stored in moveable containers. These were designed by Theodor Bogler, a student of the ceramics workshop. The moulded ceramics were the result of a successful collaboration with the industrial stoneware manufacturer Velten-Vordamm. The storage jars, however, had been preceded by earlier versions designed by Joseph Maria Olbrich, the Waechtersbach ceramics factory and Erika von Scheel. ANKE BLÜMM

Theodor Bogler, Storage jars for the Haus Am Horn,
Velten-Vordamm stoneware manufacturer, 1923

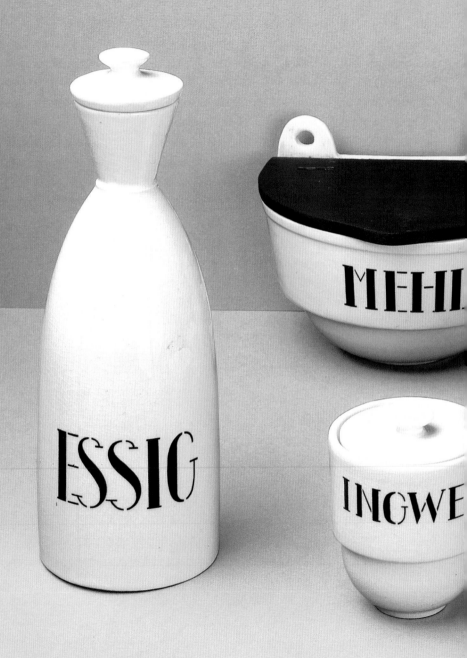

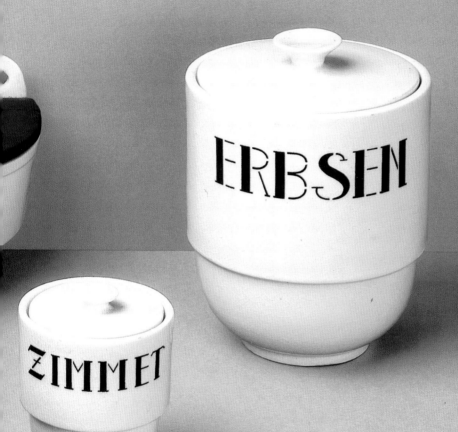

Practical and elegant: The bathroom

Having a bathroom in one's apartment was a luxury around 1900. If there was one, it was usually integrated into the bedroom and its design corresponded to the taste of the period. The most ubiquitous utensils for personal hygiene were washing basins, jugs and trays which were usually arranged on washing tables and fitted with matching towel rails. Around 1870 municipal utility companies started installing water lines into private apartments, yet most residents still had to visit public bathing houses to take a shower or bath.

Seldom did students at the Bauhaus have access to a private bath and therefore had little choice but to use Weimar's public bathing houses. However, because the entrance fees were so high and few students could afford them, they approached the management of the Bauhaus in 1922 with a request to instal a 'shower bath' at the school. In their petition, they explained that their wish arose from 'creativity-building, hygienic and moral grounds'. The school was unable to grant their wish, but it succeeded at least in negotiating reduced prices for students of the Bauhaus at the Weimar Parkbad.

In new buildings, such as the Haus am Horn, bathrooms were a standard feature. The faucets, basins and bathtubs were industrially manufactured in large batches. Their surfaces were bright, shiny and easy to clean. The Junkers company in Dessau produced the modern boilers and radiators. The task of the Bauhäusler was to find a way to integrate a modern, fully equipped bathroom into such a small space. In the end, they found inspiration for their designs in the wash cubicles in trains and ships.

The door handles installed in the Haus am Horn were also standardised, serially manufactured products, albeit designed by Walter Gropius. Although they appear identical, their dimensions and materials varied over the course of the long production phase. The cool, smooth character of the easy-to-clean materials used in the bathroom can also be found in the kitchen appliances. And like the kitchen, the bathroom was not a living area nor was it integrated

Bathing register of Bauhäusler for use of the Parkbad, 1922

into a room of the house, but rather it was designed to exclusively serve its specific function. UTE ACKERMANN

The large-scale construction kit: Modular systems at the Bauhaus

One of the fundamental design ideas of the Bauhaus involved combining various modules into new forms. Exchanging and repositioning these modules was considered key to rationalising the design process. One can see how this approach was applied, for example, in the combination teapot by Theodor Bogler, the shipbuilding game

by Alma Siedhoff-Buscher and the iconic Wagenfeld lamp. An example of this principle in architecture was Walter Gropius's Large-Scale Construction Kit. The system allowed architects to create various building forms using six standardised room units.

Gropius recognised that there was a demand for affordable, high-quality housing which could offer every family a wholesome living environment. To solve the housing problem, he broke with traditional building methods in favour of technological advances that made it possible to manufacture buildings en masse. The individual room units could be manufactured in large quantities in factories, after which they could be positioned as desired at the construction site. Gropius compared his idea of building with assembling components of a machine.

As these room units could be arranged in many different ways to fulfil a variety of functions, Gropius wanted to meet the individual needs of the inhabitants while maintaining a diverse palette of architectural designs. The Large-Scale Construction Kit consciously avoided dictating a 'uniform lifestyle or housing design', as Gropius explained in his essay on the residential building industry in Adolf Meyer's Bauhausbücher, vol. 3, entitled *An Experimental House by the Bauhaus in Weimar* (1925).

After his construction-kit design was not selected in a competition for the Haus am Horn, Gropius had the opportunity to

Walter Gropius and Fred Forbát, Model serial house, Baukasten im Grossen (Large-Scale Construction Kit), 1923, from *Ein Versuchshaus des Bauhauses* (*An Experimental House by the Bauhaus in Weimar*), Bauhausbücher 3, 1925

MODELL ZU SERIENHAUS S. 8 (1. 2. 3. 4.)

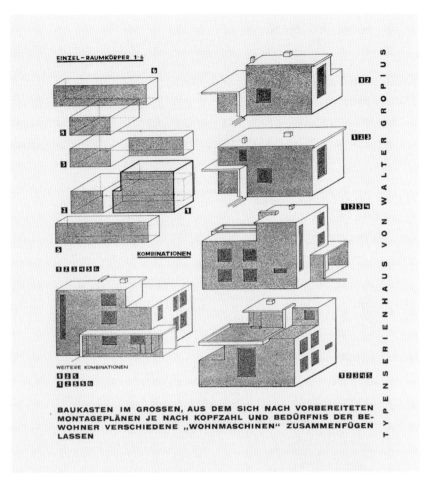

EINZEL – RAUMKÖRPER 1-6

KOMBINATIONEN

WEITERE KOMBINATIONEN

TYPENSERIENHAUS VON WALTER GROPIUS

BAUKASTEN IM GROSSEN, AUS DEM SICH NACH VORBEREITETEN MONTAGEPLÄNEN JE NACH KOPFZAHL UND BEDÜRFNIS DER BEWOHNER VERSCHIEDENE „WOHNMASCHINEN" ZUSAMMENFÜGEN LASSEN

Serial homes as a model, Walter Gropius and Fred Forbát, Baukasten im Grossen (Large-Scale Construction Kit), 1922–23, from *Ein Versuchshaus des Bauhauses* (*An Experimental House by the Bauhaus in Weimar*), Bauhausbücher 3, 1925

put his concept to the test in Dessau. The construction-kit idea is evident in the Masters' Houses and in the concept of the industrial production line for the Dessau-Törten Estate. Unfortunately, the mass production of the housing units didn't work as he had planned. Nonetheless, the idea of designing buildings based on the construction-kit principle is still being implemented and modified to this day. JOHANNES SIEBLER

Furniture systems: The living room

The living room in the Haus am Horn was the largest room, situated at the centre of the house. This is where family life took place. One could enter from all four sides, which meant that there was no space for bulky armchairs or superfluous decorations. It was important that the furnishings appeared permeable and delicate and didn't obstruct the room. Their design was based on functionality and ergonomics. Inspired by the Red Blue Chair by the Dutch De Stijl artist Gerrit Rietveld (1918), Marcel Breuer designed his famous Slatted Chair ti 1a. Breuer explained that his idea was to provide comfortable seating using the most basic construction possible. He hoped to achieve greater comfort by slightly tilting the seat and backrest and prevent unpleasant pressure on the spine using elastic fabric straps across the back. Unfortunately, the Slatted Chair ti 1a was not exactly a huge financial success. In a critique published in 1925, George Grosz wrote: 'The pieces of furniture from the Bauhaus are masterfully constructed, yet one would rather sit on some mass-produced chair made by an anonymous carpenter – for it is more

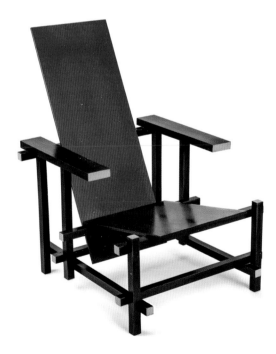

Gerrit Rietveld, Red Blue Chair, 1917/23, acquisition from the Design-Sammlung Ludewig, Berlin

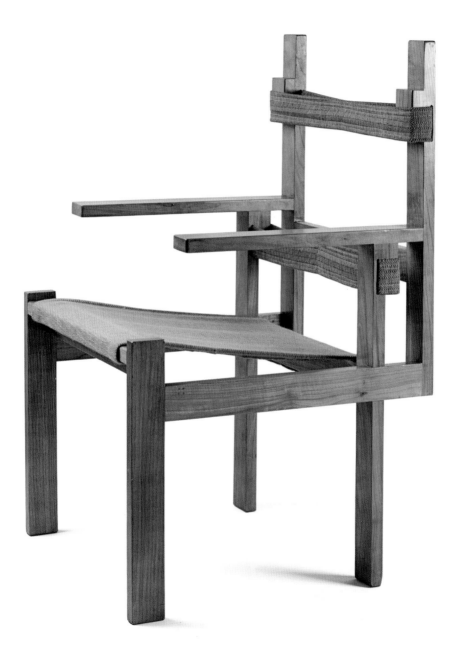

Marcel Breuer, Slatted Chair, 1922–24, purchased from the Staatliches Bauhaus Weimar in 1925

comfortable than one designed by a Bauhaus builder indulging in technical romanticism.'

New furniture had to meet the demands of modern lifestyle in terms of flexibility. Designers developed modular furniture systems which could be expanded and adapted to one's changing needs by purchasing additional pieces. The successor institution to the Bauhaus in Weimar, the Staatlichen Hochschulen für Baukunst, bildende Kunst und Handwerk (State College of Trades and Architecture)

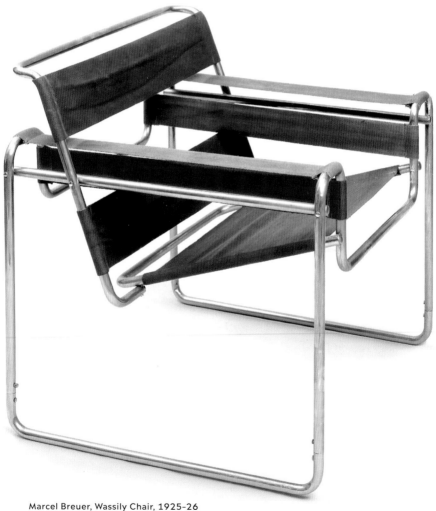

Marcel Breuer, Wassily Chair, 1925–26

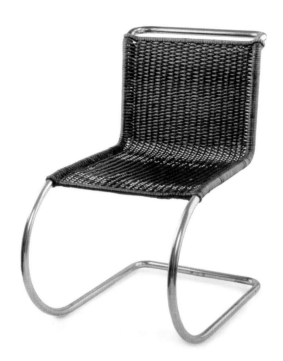

Ludwig Mies van der Rohe, Stuhl MR 10, Berliner Metallgewerbe Joseph Müller (Ausführung), 1928

headed by Otto Bartning from 1926 to 1930, offered such a modular furniture programme. Catalogues and advice books were available from other manufacturers as well, featuring modern interior designs with corresponding furniture, dishware and lamps. The Bauhaus also marketed its products in a 'Catalogue of Models'. The Slatted Chair ti 1a was one of the featured pieces. The development of tubular steel furniture in cooperation with the Junkers-Werke in Dessau did much to professionalise the relationship between the Bauhaus and industry. Despite initial scepticism, Bauhaus tubular furniture eventually found its way into the product lines of various furniture manufacturers.

Today numerous pieces of Bauhaus furniture have not only become top-selling design icons, but also well-loved items of daily use which many are reluctant to let go of. It appears that their owners have found rather bizarre ways of prolonging their product life. UTE ACKERMANN

Children's closet and puppet theatre: Alma Siedhoff-Buscher, the great designer of children's toys

'The child of today is different than a child one hundred years ago – not in essentials, but certainly a different one. Children today must process a far larger array of impressions every day.' These words sound quite contemporary, but in fact, were penned by Alma Siedhoff-Buscher in 1925 for the special issue 'Bauhaus Weimar' in the publication series *Junge Menschen* (*Young People*).

Born in 1899, she completed her first stage of education at the Schule Reimann (Reimann School) in Berlin from 1917 to 1922, one of the accredited training centres in the field of arts and crafts, as well as the teaching facility at the Kunstgewerbemuseum (Museum of Decorative Arts) Berlin. In spring 1922 she enrolled at the Bauhaus in Weimar and, despite her extensive prior education, was

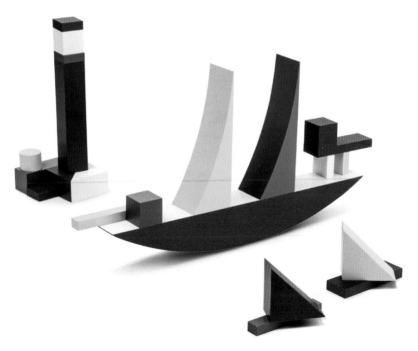

Alma Siedhoff-Buscher, Shipbuilding Game, c.1923, later re-edition

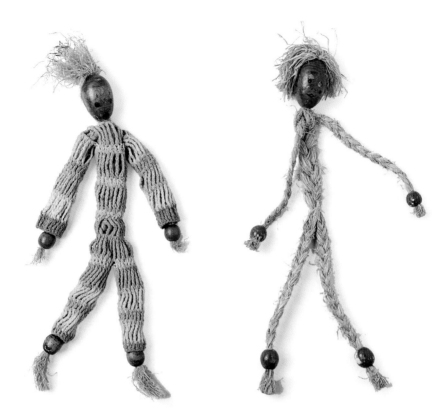

Alma Siedhoff-Buscher, Bead dolls, c.1924, left doll on loan from Bauhaus.Weimar.Moderne. Die Kunstfreunde e.V.

required to take the mandatory preliminary course taught by Johannes Itten. Upon completion, she met the fate shared by so many other women at the Bauhaus: she was assigned to the weaving workshop. Only after submitting a special request was she permitted to join the wood-sculpting workshop instead.

Alma Buscher, who married her classmate Werner Siedhoff in 1926, had already begun designing children's furniture and toys during her studies. Several of these are now established design classics of the twentieth century. Some of her best-known toy designs are still produced today, for example, the Small Shipbuilding Game and the robust, floppy bead dolls, which she registered with the Reichspatentamt (German Imperial Patent Office) in 1926. She was inspired by progressive education and especially by Friedrich

Peter Keler, Cradle, 1922

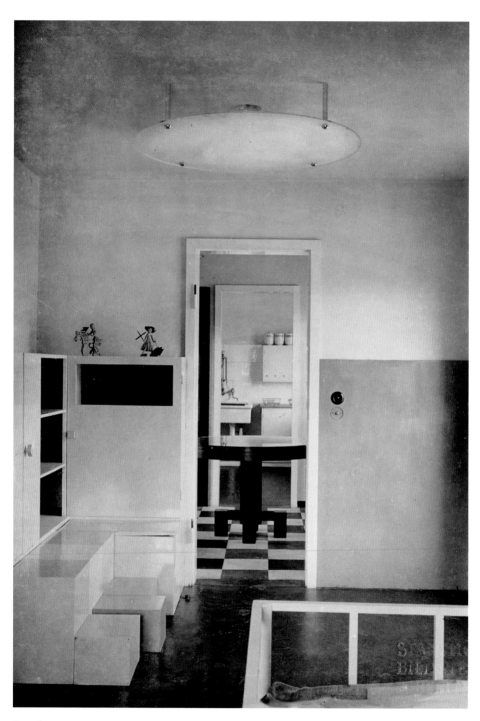

Staatliche Bildstelle Berlin, Children's room in the Haus Am Horn, 1923 (photography)

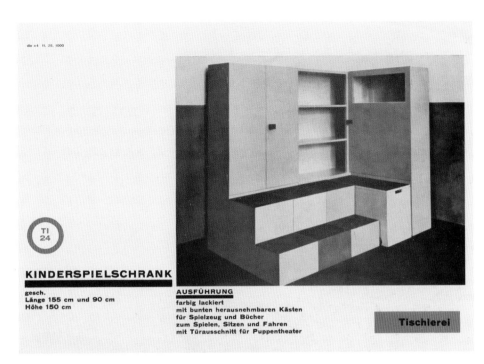

Alma Siedhoff-Buscher, Children's toy closet TI 24, 1925

Fröbel's appeals for child-friendly materials which stimulate the child's imagination and enable her to explore the world.

One of Buscher's most impressive creations is the children's toy closet which she designed for the Haus am Horn. In 1925 the Bauhaus added the closet under the name 'TI 24' in limited batches to its 'Catalogue of Models', with which the school marketed a series of Bauhaus products. The toy closet seemed to perfectly fulfil the economic, design-orientated and pedagogical requirements that customers expected from children's furniture. It was extremely practical in that it 'grew with the children', first as a place for storing toys and later for books. Thanks to the cut-out in the door, the closet could be converted into a puppet theatre. The oversized building blocks could be arranged as benches, tables and chairs, and an elongated block with wheels doubled as a toddler-sized toy train. László Moholy-Nagy gave the toy closet a raving review in a 1924 newspaper article, praising its 'creative self-affirmation as the basis

of elementary living expression'. Unfortunately, its success never translated into any financial returns for Alma Buscher. That same year, Gropius rejected her request for a studio and later a position at the Bauhaus. She initially maintained ties to the Bauhaus as a freelance designer, but after 1928, she followed her husband, whose profession as a dancer and actor required them to change their place of residence multiple times. ULRIKE BESTGEN

The *Bauhaus-Ausstellung* of 1923: A landmark event

It had to be a success. Under the cloud of crushing hyperinflation, the Bauhaus staged a major exhibition in Weimar from 15 August to 30 September 1923. The state government had agreed to provide additional funding if the school organised an exhibition of its accomplishments. Many of the instructors at the Bauhaus thought it was too early to hold such an exhibition, but Walter Gropius saw it as a great opportunity. He directed all the school's resources to achieving this ambitious and challenging goal.

With a programmatic speech entitled 'Art and Technology – A New Unity', Gropius kicked off the *Bauhaus-Ausstellung*. Its extensive programme included lectures, exhibitions, music, films, light shows and theatre performances. The Haus am Horn, fully constructed in just four months, was presented as an exhibition venue and model house, for which members of the Bauhaus created pieces of furniture for the various rooms. Events were held at other venues in Weimar, while paintings and sculptures by Bauhaus students and staff were displayed at the Grossherzogliche Museum (today, the Neues Museum Weimar). Wall decorations by Joost Schmidt and Herbert Bayer were presented in the school's main building, and another by Oskar Schlemmer was displayed in the workshop building. On the upper levels of the main building and in the Oberlichtsaal, visitors could view the final projects from the preliminary course and items produced in the workshops. The director's office nearby was refurbished in the spirit of the Bau-

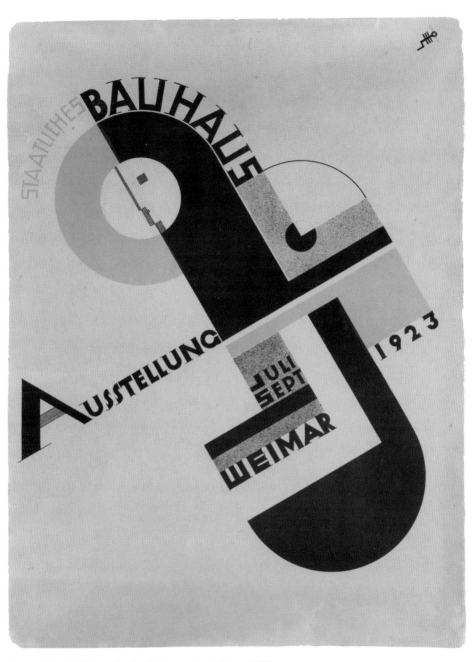

Joost Schmidt, Poster for the *Bauhaus-Ausstellung*, 1923

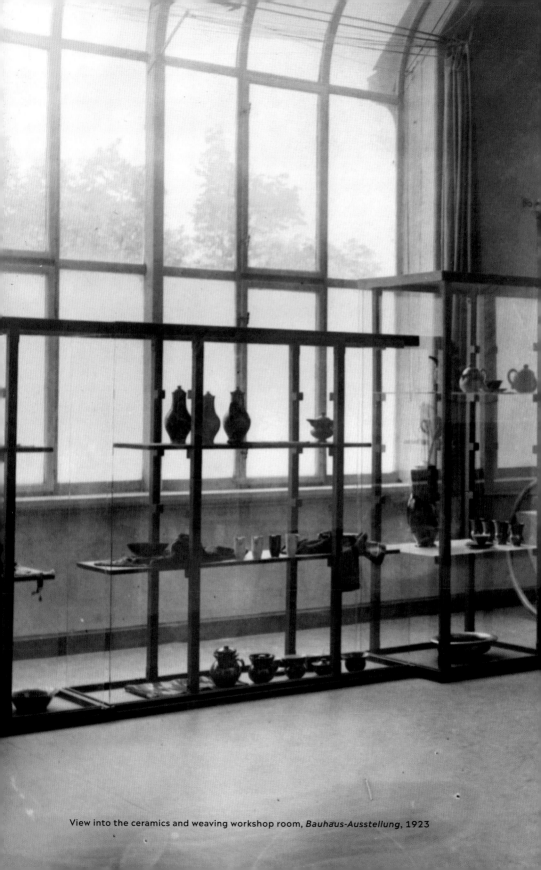

View into the ceramics and weaving workshop room, *Bauhaus-Ausstellung*, 1923

haus programme, but wasn't entirely ready for the opening of the exhibition.

Walter Gropius also organised the first international architecture exhibition, which was presented in the first-floor corridor and in the two adjacent lecture halls. It was significant in that it presented an overview of national and international developments in contemporary architecture, which rose above and beyond the concept of the exhibition demanded by the state authorities. Staging such an exhibition under the particular political circumstances so soon after the First World War was a ground-breaking step of great socio-political relevance. Gropius's intention was to present the 'dynamic-functional side' of architecture, free of 'ornamentation and profile'. In this regard, he propagated a new concept of architecture that distanced itself from classical styles and traditional design methods.

The theatre workshop prepared an extensive programme for the Stadttheater Jena. Schlemmer's *Triadic Ballet*, which premiered in Stuttgart in 1922, was performed in a slightly modified form at the Deutsches Nationaltheater (DNT) in Weimar. Walter Gropius himself went to great lengths to organise an outstanding musical programme featuring works by Igor Stravinsky, Paul Hindemith, Ernst Krenek and Ferruccio Busoni, amongst others.

The *Bauhaus-Ausstellung* of 1923 was a huge success and generated national and international attention for the Bauhaus. However, there were some – also in the press – who criticised and even disparaged the innovative and sometimes revolutionary moments of the exhibition. ULRIKE BESTGEN

Exhibition on international architecture with works by Walter Gropius (right)
and Mies van der Rohe (left), 1923

FAILURE? AND WHAT REMAINS?

Lyonel Feininger,
Cathedral, wood-
cut for the Mani-
festo and Pro-
gramme of the
Staatliches
Bauhaus Weimar,
1919, Klassik
Stiftung Weimar

DID THE BAUHAUS, labelled the most influential school of design of the twentieth century, fall victim to its own high standards?

Following the devastating experiences of the First World War, revolution and political recalibration, there were some who harboured reservations and even levelled strong criticism towards the noble, social-philosophical goal of the Bauhaus to create a more humane society. Were artists and designers truly suited to furthering this goal? In a speech by none other than Paul Klee in January 1924 marking the opening of an exhibition of his works at the Kunstverein Jena, he claimed the school had just started making progress towards accomplishing this great project: 'We don't yet have this last strength, for there is no people to support us. But we are looking for a people, we started over there at the Staatliches Bauhaus. We started with a community to whom we devote everything we have. We can do more than that.' What is revealing in this statement is the romantic notion of a community which Gropius saw embodied in the ideal of the medieval builder's hut and in the collaborative spirit of the Bauhaus with its division of labour. It was around this time that the Bauhaus was discussing the programmatic ramifications of community. The romanticised view of an isolated community was confronted with the ideal of forging a close relationship to society.

In this tense situation, the confrontation with reality produced a sobering realisation. After the Bauhaus presented its products at the Leipzig Trade Fair in the spring and autumn of 1924, László Moholy-Nagy noted that the production costs were too high. Instead of producing goods for mass consumption, the Bauhaus was far more occupied with catering to the poorly selling luxury market.

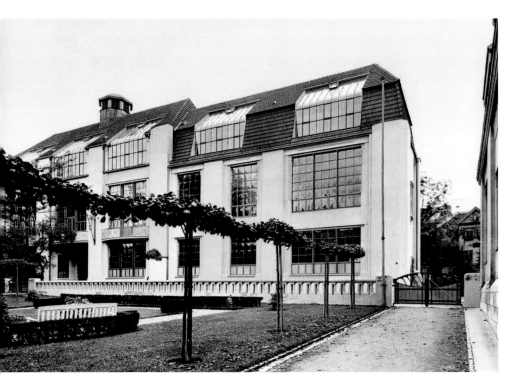

Grand Ducal Saxon College of Fine Arts, Weimar, architect: Henry van de Velde, photo: Louis Held, c.1911, Klassik Stiftung Weimar

Therefore, it was necessary, he argued, to promptly establish contact with industry in order to engage in serial manufacturing: 'There is no more important point than this, for it determines whether the work of the Bauhaus stands or falls. The Bauhaus has indeed succeeded in producing useful and truly life-serving products in accordance with its specified goals; now it's about marketing them commercially.'

But the allegation that the Bauhaus produced luxury goods, which though elegantly designed, few could afford, cannot be dismissed. Hannes Meyer, the second Bauhaus director from 1928 to 1930 after Walter Gropius's departure, emphasised once again the social obligation of architecture and design in his inaugural address: 'Is our work being influenced from without or from within? Do we want to orientate ourselves to the needs of the outside world,

help shape new ways of life, or do we want to be an island which might promote [personal values, but] whose positive productivity is questionable?' Meyer believed in meeting 'the needs of the people over the needs of luxury'; he reformed the curriculum, focussed the instruction on industry and standardised production and introduced new subjects. As an architect, he favoured cooperative goals. But due to his ties to the leftist scene, Meyer was dismissed without notice in 1930 for political reasons.

Mies van der Rohe assumed the post of director until the Bauhaus was permanently shut down in 1933. During his term in office, he focussed on offering professional architectural training and, in so doing, departed from the original visionary-utopian orientation of the school and the lofty aims of his predecessor.

Perhaps the Bauhaus student Max Bill summed it up best in 1928 when, asked what he thought of the Bauhaus, he responded: 'Bauhaus is an intellectual, progressive direction, an attitude that

South view of the Bauhaus building, Dessau, architect: Walter Gropius, photo: Erich Consemüller, c.1927, purchase made possible by Alfried Krupp von Bohlen and the Halbach-Stiftung

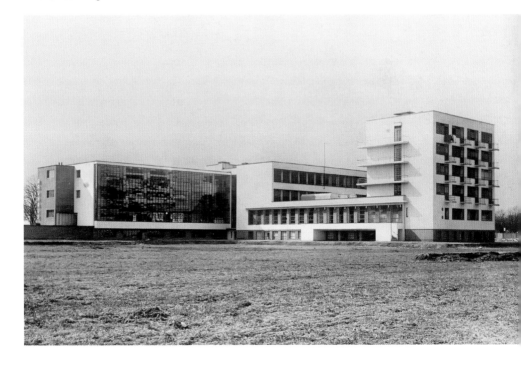

one could also call a religion.' In other words, a secular creed which produced its own mythos and thus could also ideologically fail.

In the real world, though, the Bauhaus was brought down by the political antagonism of a tumultuous Weimar Republic, and that three times. With regard to the Bauhaus in Weimar, the parliamentary elections in Thuringia in February 1924 utterly changed the situation; right-wing conservatives took control of the parliament, which resulted in renewed and increasing attacks on the school by the Handwerksgilde (Craftsmen's Guild) and the Weimar Künstlerbund (Artists' Association). As a 'precautionary' measure, the government terminated Gropius's employment contract as well as those of the Bauhaus masters, effective 31 March 1925, and cut the school's operating budget in half. On 26 December the director and Bauhaus masters issued a public statement in which they announced that the Bauhaus in Weimar would be dissolved on 1 April 1925 upon termination of their contracts. The successor institution headed by Otto Bartning, the Staatlichen Hochschulen für Baukunst, bildende Kunst und Handwerk, did hire a number of former Bauhaus students as instructors and continued pursuing many of the ideas of the Bauhaus. However, it too was completely overhauled in 1929–30 when the NSDAP joined the governing coalition in Thuringia. The decree 'Against the Negro Culture, for the German Heritage' issued on 5 April specified the future National Socialist cultural policy goals in Thuringia. The school's new director was Paul Schultze-Naumburg, an architect with aesthetically and ideologically radical views and the author of a 1928 diatribe against modern art titled 'Art and Race'. In a 'cleansing campaign', undesired instructors were let go, numerous students left the college, and 'degenerate' art works were allegedly destroyed. In 1932 Schultze-Naumburg supported Nazi representatives as they prepared to close the Bauhaus in Dessau. The decision was made by the municipal council on 22 August 1932 and took effect on 1 October 1932. For a time, Mies van der Rohe was able to run the Bauhaus as a private institution in a former telephone factory in Berlin-Steglitz, but even these plans were foiled by Adolf Hitler's inauguration as Reich Chancellor on 30 January 1933. Facing an

Iwao Yamawaki, *Der Schlag gegen das Bauhaus* (*Strike against the Bauhaus*), 1932

economically desolate situation, incessant smear campaigns against the Bauhaus and pressure from the school authorities to reform the curriculum and restructure the faculty, the teaching staff made the decision to permanently close the Bauhaus in Berlin – a final act of self-assertion in its failure to survive the socio-political developments!

Bauhaus building in Berlin-Steglitz, photo: Howard Dearstyne, 1932

Yet failure doesn't mean the end. In the following years, the Bauhäusler met with an extremely diverse array of setbacks and successes; their fates and journeys reflect the historical tides of the times. Walter Gropius and Mies van der Rohe initially offered their services to Germany's new political masters, participated in architectural competitions or – like other Bauhäusler – designed various parts of major propaganda exhibitions. Gropius left Germany in 1934 for Great Britain and then the United States, and Mies followed in 1938. In the aftermath of the global financial crisis, Hannes Meyer and several Bauhaus students went to Moscow in 1930, where major commissions were to be had in post-revolutionary Russia. However, they soon became targets of Stalinist terror. Meyer left Russia in 1936, and in 1939 moved from Switzerland to Mexico, where he had received a professorship.

Many Bauhäusler retreated into inner emigration, others left Germany, and others made their peace with the Nazi regime, accept-

ing commissions and employment. Some were arrested on account of their Jewish background or political views, sent to concentration camps and murdered.

Whenever someone wished to present a modern image of themselves – be it in industrial construction, artisanal design, industrial design, or advertising – the Nazis readily adopted the innovative architectural ideas and designs of the Bauhaus even though these were officially censured as Jewish or Bolshevist. The fight against the visual arts, however, raged on. Even Paul Klee, who had once envisioned a future of great promise, suffered this fate. Deemed politically unreliable and condemned as a degenerate artist, his professorship at the Düsseldorf Art Academy, which he received after leaving the Bauhaus in 1931, was abruptly terminated in 1933.

What is left of the Bauhaus? As Mies van der Rohe astutely noted, the Bauhaus became a global idea. But is it an attitude? What remains? This question can be answered in very different ways depending on whether you're a company specialised in reproducing Bauhaus products, an art gallery, a university-affiliated institute, or a museum. The reception of the Bauhaus is not only a regionally and nationally relevant topic; it is an international phenomenon of inexhaustible scope relating to issues of architecture, industrial design, education, the visual arts, photography and theatre. Research on the Bauhaus is devoted to exploring an ever-expanding array of new aspects: the investigation of multinational networks of Bauhaus graduates and instructors, technical analyses of materials used at the Bauhaus (including their production processes, gender-related themes, considerations on the extent to which modernist developments occurred parallel to the Bauhaus at various locations around the world and post-colonial studies on the influence of Bauhaus design and Bauhaus teachings). The commemorative year events are sure to inspire research into further Bauhaus-related topics which may very well find their way into the museum. The art market for Bauhaus objects is booming, even more so now as the Bauhaus centennial approaches, as is the market for producing high-quality – and inferior-quality – reproductions of Bauhaus products.

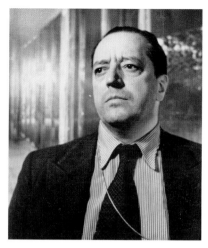

Erich Consemüller, Hannes Meyer, 1928

Werner Rohde, Ludwig Mies van der Rohe, 1934

For a museum like the Bauhaus Museum Weimar, whose narrative springs from the object it presents, the answer to the question 'What remains?' primarily lies in its own collection profile and in relation to its respective institutional history. The complex of the Weimar Bauhaus collections has long been riddled with gaps, and unfortunately still is, due to losses in the area of the visual arts. In the future, the museum will continue to intensively investigate the eras of its collection history, along with their respective objects and their individual histories.

For many years, curators in Weimar focussed on collecting items of the early Bauhaus years in Weimar, supplemented with works by Henry van de Velde, who played a pioneering role as a forerunner to the Bauhaus, and pieces produced by Van de Velde's Grossherzoglich Sächsische Kunstgewerbeschule Weimar. The Weimar collection contains only a handful of objects that portray the development of the school under Hannes Meyer, and the group of items produced under Mies van der Rohe has always been fragmentary. In 2010, thanks to the Federal Republic of Germany, Free State of Thuringia, Cultural Foundation of German States and generous support from the Ernst von Siemens Kunststiftung, the

Klassik Stiftung Weimar was able to acquire the collection owned by the design collector Manfred Ludewig. This collection provides illuminating context to the development of the Bauhaus and sheds light on the genesis of functionalism. In 2017 and 2018 the Klassik Stiftung Weimar succeeded in acquiring an excellent collection of furniture designed by Mies van der Rohe. The result is a fascinating perspective of how the design ideal of modern living developed over time, starting from Henry van de Velde to the Haus Am Horn to Mies van der Rohe's prominent commissioned works of famous villas like Haus Esters in Krefeld and Villa Tugendhat in Brno. The historical buildings of modernism in Weimar, such as the Haus Hohe Pappeln, the Nietzsche-Archiv and the Haus Am Horn, also reflect this aspect in correlation to the museum's narrative, allowing visitors to sensually experience, so to speak, the history of modern living. Furthermore, numerous donations and loans of paintings, sculptures and graphic works have helped close the existing gaps in the area of the visual arts to a large extent.

Against this background, the curators of the exhibition have come to the unusual decision to allow the achievements of the three Bauhaus directors, Walter Gropius, Hannes Meyer and Mies van der Rohe to answer the question 'What remains?' And this in the wrong spatial order, as Hannes Meyer 'takes the stage' on the top floor of the Bauhaus Museum after Mies van der Rohe. Because the chronologically linear narrative of the Bauhaus seemed outdated and the museum focusses on the ideas and processes developed at the school, this arrangement might be a more fitting way to examine the history of the institution. After all, a museum-based narrative is always a construct of curatorial approaches to history. In a project room featuring perspectives on future temporary exhibitions on the subject 'What remains?', we will continue weaving the narrative of the Bauhaus Museum. Look forward to more surprises ahead! ULRIKE BESTGEN

Walter Gropius: Does the Bauhaus belong in a museum?

The 'Bauhaus' has been collected in Weimar since 1919. The first item acquired by the State Art Collections in the founding year of the Bauhaus was the student journal *Der Austausch* (*The Exchange*). Student representatives presented the new museum director Wilhelm Köhler with a freshly printed copy of the magazine. Köhler not only added it to the museum's holdings, but also took out a subscription to the magazine for the library. He was extremely interested in modernist art and tried to drum up enthusiasm for it among Weimar's museum patrons. To this end, the Bauhaus served as a kind of multiplier.

When the Bauhaus was forced out of Weimar in 1925, museum director Wilhelm Köhler proposed incorporating the Bauhaus creations into the art collections. He also suggested storing the

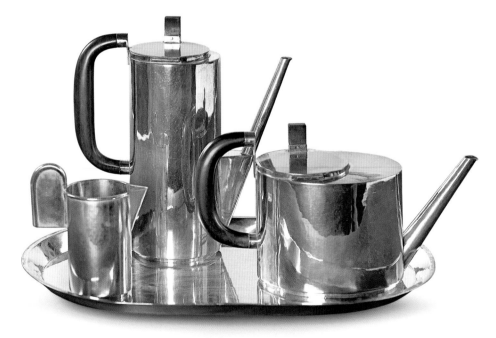

Wilhelm Wagenfeld, Coffee service, 1924

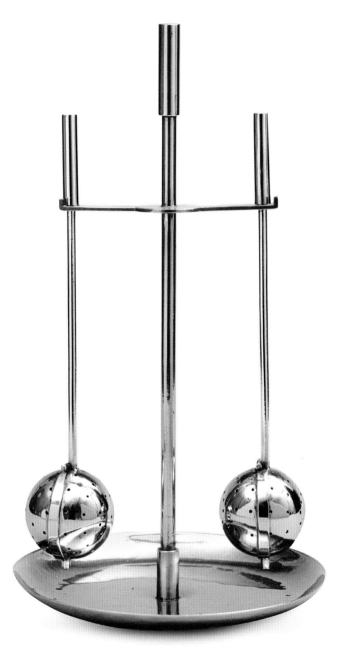

Otto Rittweger, Wolfgang Tümpel, two tea ball infusers with holder MT 20, 1924

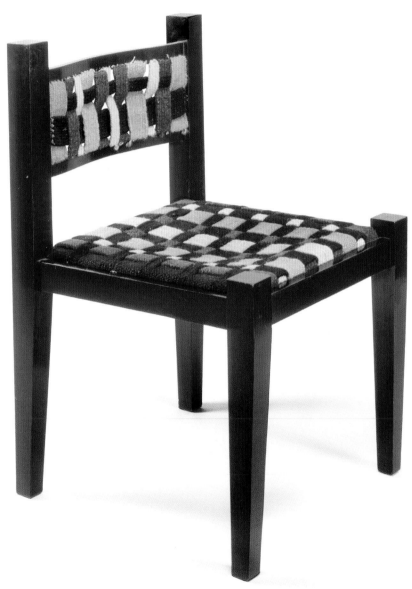

Marcel Breuer and Gunta Stölzl, Chair, 1921

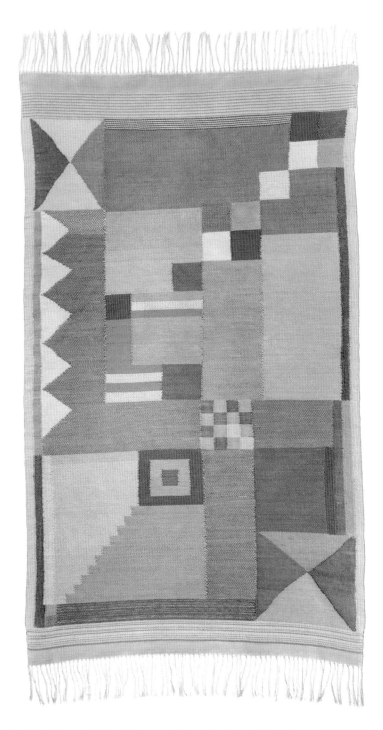

Benita Koch-Otte and Helene Börner workshop, Rug for a children's room, 1923–25

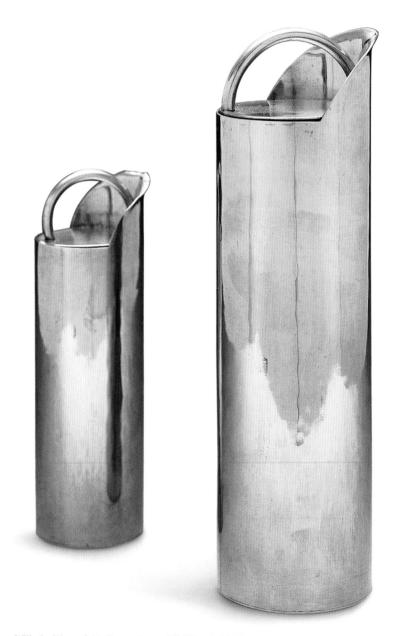

Wilhelm Wagenfeld, Tea canisters MT 38 and MT 39, 1924

printed materials and photography in a Bauhaus Archive which would be available 'for all inquiries and future research … on the inner history of the Bauhaus'. A critical examination of the Bauhaus was planned from the start, for Köhler not only wanted the collection to highlight its achievements but also examples of occasions when the 'workshops and directors took the wrong track'.

Gropius and Köhler jointly selected some 170 workshop pieces for the museum, a decision that consequently influenced the image of the Weimar Bauhaus in posterity. And thus, they established a new collection which is now the oldest museum-based Bauhaus collection in the world, authorised by Gropius himself.

While numerous works, including several by Paul Klee, Wassily Kandinsky and Gerhard Marcks, were confiscated by the Reichskulturkammer (Reich Chamber of the Fine Arts) in 1937, they survived the Nazi years relatively unscathed. Hidden away in a storage room of the Stadtschloss, the sealed crates were finally opened and inventoried in the 1950s. The completely preserved works now comprise the heart of the museum. As for whether the Bauhaus belonged in a museum, Gropius responded with an unequivocal YES. UTE ACKERMANN

The Bauhaus in pictures

What sticks in most people's minds are the images of the Bauhaus in the media. Nobody knew this better than Walter Gropius, who became acquainted with modern product advertising in 1908, working as an assistant in Peter Behrens's studio. The rapid development of photography helped him promote the Bauhaus in Weimar. Gropius, a brilliant manager and PR mind, came up with the idea in 1921 of photographing typical works produced at the school as documentation for an archive. In anticipation of the planned *Bauhaus-Ausstellung* in 1923 and trade fair presentations, for which professionally made photos were required, the Bauhaus commissioned several photo studios with the task. Lucia Moholy, wife of László Moholy-Nagy, began working as an apprentice at the Eckner photo studio in Weimar in summer 1923. She produced numerous pictures printed in the famous Bauhaus Albums, which are now kept at the Bauhaus-Universität Weimar. She was the first to professionally pursue photography at the Bauhaus and is credited with laying the cornerstone for cutting-edge product photography.

In Dessau, Walter Gropius commissioned the Bauhaus student Erich Consemüller to continue this important job. Consemüller produced some 300 photographs documenting the school's achievements. He took photos with a plate camera and numerous snapshots with his private Leica 35 mm camera. His impressive pictures present a view into the world of teachers and students and examples of the school building architecture, theatre experiments and various objects produced in the workshops and in the preliminary course by Josef Albers. For Gropius, the documentary photos were an important component of the public relations work at the Bauhaus and served to enhance the school's image in the media as a place of modern, functional design and architecture. Several photos by Erich Consemüller became icons of photographic history. The lady in the 'Wassily Chair' designed by Marcel Breuer is most likely the student Immeke Schwollmann. Wearing a mask from one of Oskar Schlemmer's stage productions, she represents the (anonymous) young, modern-day woman. ULRIKE BESTGEN

Josef Knau, Samovar with spirit stove and extract pot, metal workshop at the
Weimar Bauhaus, photo: Lucia Moholy-Nagy, 1924

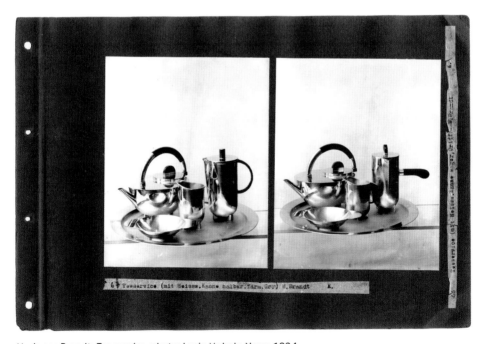

Marianne Brandt, Tea service, photo: Lucia Moholy-Nagy, 1924

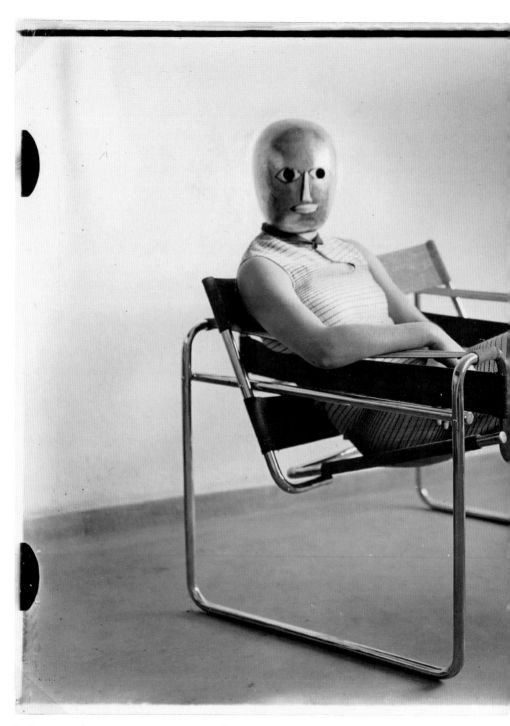

Bauhaus scene (probably Immeke Schwollmann), photo: Erich Consemüller, c.1927,
gift from Wulf Herzogenrath, Berlin

Ludwig Mies van der Rohe: Designs for modern life

What remains? Ludwig Mies van der Rohe, the third Bauhaus director (1930–33), stood for the international image of the Bauhaus. Today he is widely regarded as one of the most influential architects of modernism. During his term as Bauhaus director in Dessau and Berlin, he focussed largely on architectural training. A large number of his designs from during and after his time at the Bauhaus reflect his attitudes on modern life and the internationality of the so-called 'Bauhaus style'. In hindsight, Mies van der Rohe described the Bauhaus as a global idea and, in contrast to Walter Gropius, saw the Bauhaus as a concluded development.

The pavilion that Mies van der Rohe created for the *International Exposition* in Barcelona in 1929 is one of the key buildings of modernism. Mies was hired by the General Commissioner of the

Pavilion of the German Empire at the *Barcelona International Exposition*, architect: Ludwig Mies van der Rohe, photo: Berliner Bildbericht, 1929, loan from a private collection

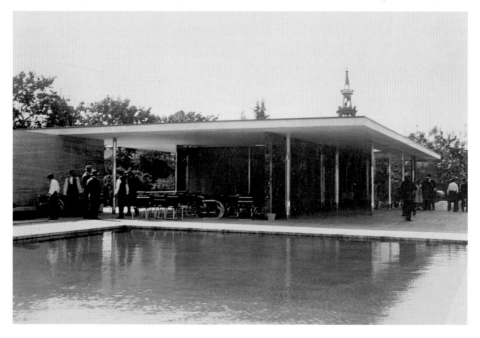

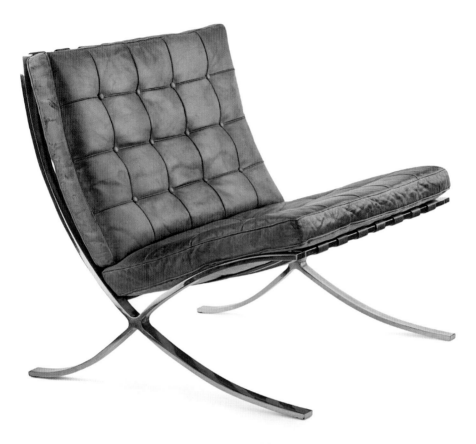

Ludwig Mies van der Rohe, Barcelona Chair MR90, 1929,
loan from a private collection

German Empire to design a pavilion that would represent the
progressive and cosmopolitan character of the young German
democracy at the world exposition. Mies designed a stool and chair
for the interior furnishings of the pavilion. Both were part of a
Gesamtkunstwerk of flowing spaces, interior and exterior perme-
ability, exquisite materials and carefully arranged furniture. The
chair and stool are undeniably just as iconic as the pavilion. Crafted
with flattened steel and based on ancient models, both pieces
beautifully embody the convergence of tradition and modernism.
The original chairs from the Barcelona pavilion have been lost to

posterity. The exemplar shown here belonged to the estate of James Johnson Sweeney, an art critic and collector and Mies's personal friend. Sweeney worked as a curator at the Museum of Modern Art and later served as director of the Solomon R. Guggenheim Museum in New York. In the 1920s he had his New York apartment equipped with furniture designed by Mies.

Parallel to the Barcelona pavilion, Mies also designed the home of the entrepreneurial couple Fritz and Grete Tugendhat in Brno. The Villa Tugendhat is one of the world's most famous examples of modernist architecture. The steel-frame structure was a feat in residential construction. The open floor plan created a smoothly flowing room sequence, and the interior and exterior spaces were connected by retractable glass elements. The furnishings were marked by elegance and exclusivity. 'We loved the house the moment we saw it', recalled Grete Tugendhat. On 12 March 1938, the day Germany annexed Austria, the Jewish family made the

heartbreaking decision to emigrate to Switzerland, and in 1941 moved to Venezuela. Fritz Tugendhat was able to take some furniture with him, including the bridge table, which remained in the family. The building was later used for various purposes during and after the Second World War. In 2001 it became a UNESCO World Heritage Site and was extensively restored from 2010 to 2012.

Mies van der Rohe recognised the potential of new media, specifically photography, and readily made use of it to promote his projects. Many of his selected and widely publicised photos, such as those of the Barcelona pavilion and Villa Tugendhat, have since become legendary. ULRIKE BESTGEN

Ludwig Mies van der Rohe, Bridge table from the Villa Tugendhat, 1930, loan from Ruth Guggenheim-Tugendhat

Hannes Meyer – rethinking the world: 1926 and today

Hannes Meyer, second Bauhaus director (1928–30), was a Swiss architect, proponent of the cooperative idea, Communist, a forward thinker and a provocateur. In his pursuit of an all-encompassing design for modern life, he was an influential but also ambivalent protagonist of his time. He reflected on the developments of the 1920s and drew conclusions on how these would impact the future. His thoughts were often radical; he proposed dissolving national boundaries and making all people 'citizens of the world'; with advancing technology, he saw apartments becoming 'living machines', and, in his opinion, emotions and one's inner spiritual life played no role in architecture.

Hannes Meyer summarised many of his ideas in his article 'Die neue Welt' (The New World) published in the magazine *Das Werk* in 1926. This text is displayed in the last room of the exhibition and is the object of an historical reflection. At the same time, it offers us a chance to examine the possibilities and potentials of contemporary lifestyle design. In other words, it allows us to venture beyond the subject of pure design and explore socially relevant approaches and challenges. How do we view Meyer's assertions and perception of the future? What ideas are still relevant today? And how are we addressing these challenges and opportunities?

To answer these questions, visitors to the Hannes Meyer room encounter an installation which explores such topics as internationalisation, standard production, community vs. the individual and the stadium vs. the art museum and assesses their importance with respect to diverse local and supraregional groups. Historians, designers, average citizens, associations, entrepreneurs, artists, one's next-door neighbours – everyone can be an expert when it comes to designing our way of life.

The design of the room corresponds to this profile. Meyer's text forms the basis, comprised of a graphic presentation on the floor. Two platforms offer visitors different perspectives on the world;

NATAN ALTMAN, LENINGRAD
Revolutionsprojekt für die Umgestaltung eines Platzes in Leningrad, 1918

HANNES MEYER / DIE NEUE WELT

Die Nordpolfahrt der «Norge», das Zeiss-Planetarium zu Jena und das Rotorschiff Flettners sind die zuletzt gemeldeten Etappen der Mechanisierung unseres Erdballs. Als Ergebnisse exaktesten Denkens belegen sie augenfällig den Nachweis einer fortschreitenden wissenschaftlichen Durchdringung unsrer Umwelt. So zeigt das Diagramm der Gegenwart inmitten der krausen Linien seiner gesellschaftlichen und ökonomischen Kraftfelder allüberall die Geraden mechanischer und wissenschaftlicher Herkunft. Sie belegen sinnvoll den Sieg des bewussten Menschen über die amorphe Natur. Diese Erkenntnis erschüttert die bestehenden Werte und wandelt deren Formen. Sie gestaltet bestimmend unsre neue Welt.

Unsere Strassen stürmen die Autos: Von 18—20 Uhr umspielt uns auf der Trottoirinsel der Pariser Avenue des Champs Elysées das grösstmögliche Fortissimo grossstädtischer Dynamik. «Ford» und «Rolls-Royce» sprengen den Stadtkern und verwischen Entfernung und Grenze von Stadt und Land. Im Luftraum gleiten Flugzeuge: «Fokker» und «Farman» vergrössern unsere Bewegungsmöglichkeit und die Distanz zur Erde; sie missachten die Landesgrenzen und verringern den Abstand von Volk zu Volk. Lichtreklamen funken, Lautsprecher kreischen, Claxons rasseln, Plakate werben, Schaufenster leuchten auf: Die Gleichzeitigkeit der Ereignisse erweitert masslos unsern Begriff von «Zeit und Raum», sie bereichert unser Leben. Wir leben schneller und daher länger. Unser Sinn für Geschwindigkeit ist geschärfter denn je und Schnelligkeitsrekorde sind mittelbar Gewinn für Alle. Segelflug, Fallschirmversuche und Variétéakrobatik verfeinern unser Gleichgewichtsbestreben. Die genaue Stundeneinteilung der Betriebs- und Bureauzeit und die Minutenregelung der Fahrpläne lässt uns bewusster leben. Mit Schwimmbad, Sanatorium und Bedürfnisanstalt bricht die Hygiene ins Ortsbild und schafft durch Watercloset, Fayencewaschtisch und -badewanne die neue Gattung der sanitären Töpferei. FordsonTraktor und v. Meyenburg-Bodenfräse verlegen die Schwerpunkte des Siedelungswesens und beschleunigen Bodenbearbeitung und Intensivkultur der Ackererde. Bouroughs Rechenmaschine

205

Hannes Meyer, 'Die neue Welt' ('The New World'), 1926, title page, in *Das Werk* 13, 1926

one is historically reflexive, the other has a contemporary focus. The result is an exhibition space that engages in dialogue with society. It is dynamic and not least of all discursive – very much in the spirit of the historical but also the contemporary Bauhaus. MAXIE GÖTZE

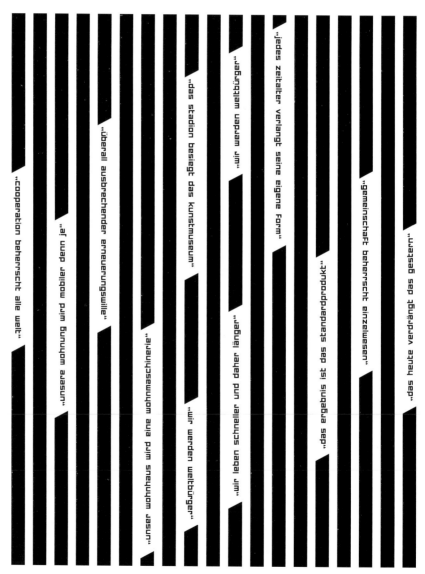

Holzer Kobler Architekturen Berlin, 2×Goldstein, Hannes Meyer – die Welt neu denken (Rethinking the world), floor graphics, 2019

Bauhaus yesterday and today:
Bauhaus from yesterday to today?

'Please show me how to do Bauhaus!' This entreaty originates from a 2015 publication by Frank Hartmann and Pierre Kramann-Musculus. The question is, what can we take and learn from the Bauhaus in the here and now?

The attempt to solve the problems of today with solutions proposed by the Bauhaus is doomed to fail. Once we put on the Bauhaus glasses, it may seem that everything can be negotiated and discussed. But when we look for specific solutions to concrete problems, we must let go of the hope that we can directly apply Bauhaus methods.

How will we live, how will we settle, what form of community do we want to aspire to? These guiding questions in the museum echo those Walter Gropius formulated in his speech on the participation of the Bauhaus at the Stuttgart Building Exhibition of 1924. The circumstances and experience which evoked these questions, however, were very different one hundred years ago. Industrialisation was in full swing, the First World War was over, and Germany had become a democracy for the first time. Therefore, we cannot expect the Bauhaus to provide a road map for our times and problems. Yet that doesn't mean we should discard it, either. Rather, we should allow the Bauhaus to inspire us, for example, by thinking about and designing the world differently. The Bauhäusler regarded upheaval as an opportunity and necessity to develop alternative solutions and venture down new paths. Today we need more space for utopian ideas – both large and small.

The eagerness to experiment at the Bauhaus can also be a source of excitement. The Bauhäusler tested materials for new uses and proposed new forms of coexistence. Recognising the potential in failure is also an integral part of experimentation. When forced to take a detour, one often catches sight of a better solution.

Similarly, we can find inspiration in how the Bauhäusler combined work and play. In 1919 Johannes Itten entitled in his very first lecture 'Our Game, Our Party, Our Work'. This became

programmatic for the activities at the Bauhaus. Not only did students intensively brainstorm and create at their drafting tables or in the workshops, they applied the principles of playing and celebrating to experiment, strengthen their community and work collaboratively. And best of all, they had fun doing it.

So let's get started! Let us celebrate our times and shape the world! VALERIE STEPHANI

ACKNOWLEDGEMENTS

We thank our institutional sponsors:
The Federal Government Commissioner for Culture and the Media, The Free State of Thuringia, The City of Weimar
For generously supporting the exhibition, we especially thank: European Regional Development Fund (ERDF) – Free State of Thuringia, German Federal Cultural Foundation (Hortensia Völckers, Alexander Farenholtz, Friederike Zobel), Sparkassenstiftung, Art Mentor Foundation, Lucerne, Bauhaus.Weimar.Moderne. Die Kunstfreunde e.V., Weimar

Our special thanks go to:
Berlin Andrew Alberts, architectural photography; Bauhaus-Archiv Berlin | Museum für Gestaltung; Prof Dr Harald Bodenschatz; DIEHL + RITTER gUG; Prof Dr Magdalena Droste; Dr Thomas Flierl; heike hanada_laboratory of art and architecture (Prof Heike Hanada and her team); Prof Dr Wulf Herzogenrath; Andrea Keiz; Janek Müller; Kulturstiftung der Länder (Dr Britta Kaiser-Schuster); Manfred Ludewig; Büro Schroeter und Berger; Tactile Studio; Dance Heritage Fund; Studio TheGreenEyl (Gunnar Green, Willy Sengewald); Studio Tomás Saraceno (Tomás Saraceno and his team); Suse Wächter; Wolfgang Wittrock; companies: Lichtvision Design GmbH; Firma Museumstechnik GmbH; Firma Fuhrmann Grafik; Firma Id3d-berlin; Architekturbüro Manfred Schasler, Berlin, Suse Wächter
Boston Prof Hans Tutschku
Cologne Theatre Collection of the University of Cologne
Dessau Stiftung Bauhaus Dessau
Dresden Staatliche Kunstsammlungen Dresden (Dresden State Art Collections), Puppet Theatre Collection (Dr Lars Rebehn)
Düsseldorf Dr Helmut Reuter, Theater der Klänge (Prof Jörg Lensing)
Erfurt Restaurierungen Andreas Manigk, Sparkasse Mittelthüringen (Dieter Bauhaus), Thuringian State Chancellery (Marita Kasper, Karla Holzheu, Daniela Lasserre), Universität Erfurt (Prof Dr Patrick Rössler)
Essen Alfried Krupp von Bohlen und Halbach-Stiftung (Dr Thomas Kempf)

Gera Kunstsammlung Gera (Holger Saupe)
Hamburg grauwert. Büro für Inklusion & demografiefeste Lösungen (Matthias Knigge), Architekturmodelle Erik Schmidt
Hannover Hamann family community of heirs, Firma AVE Verhengsten GmbH & Co
Leipzig Hirmer Verlag (Kerstin Ludolph, Ann-Christin Fürbass, Peter Grassinger), Regie Fuchs (Christian Fuchs), Heidi Stecker
Liechtenstein Stiftung zur Förderung grafischer Kunst, Liechtenstein (Dr Peter Ritter)
Markkleeberg ALEXA Audioproduktion
Mellingen Lytec GmbH
Munich Bavarian State Ballet, Ernst von Siemens Kunststiftung (Dr Martin Hoernes), Fotografie Wilfried Hösl, Heinz-Bosl-Stiftung
Potsdam MicroMovie Media GmbH
Rheinstetten 2xGoldstein GbR (Andrew and Jeffrey Goldstein)
Titisee-Neustadt Robert Brambeer, translations
Weimar Harms Achtergarde, Archiv der Moderne (Dr Christiane Wolf), Atelier Papenfuss (John Mitsching), Claus Bach, Constantin Beyer, Bauhaus-Universität Weimar (Prof Dr Winfried Speitkamp, Prof Dr Max Welch Guerra, Prof Danica Dakic and her team, Prof Dr Hans-Rudolf Meier, Jannik Noeske, Julia Otte, Prof Dr Ines Weizman), Alexander Burzik, Andrea Dietrich, Beate Dorfner-Erbs, Fotoatelier Louis Held, Michael von Hintzenstern, Stephan Illert, klangwerk am bauhaus e. V. (Prof Claudia Buder, Prof Christoph Ritter, Prof Robin Minard, Elizaveta Birjukova, Christina Meissner, Andreas Schulik, Klaus Wegener), Thuringian State Archive – Weimar Central State Archive (Dr Bernhard Post, former director, Dr Frank Boblenz), Michael Siebenbrodt, Musikgymnasium Schloss Belvedere, City of Weimar/ Department of Cultural Affairs, Stadtmuseum, Stadtarchiv, Buchenwald and Mittelbau-Dora Memorials Foundation (Prof Dr Volkhard Knigge), Jens Weber and Andreas Wolter
Zurich/Berlin Holzer Kobler Architekturen Berlin GmbH (Prof Barbara Holzer, Roland Lehnen, Sina Ramsaier, Sebastian Hübsch, Daniela Bico)

And finally, a very special thank you to the many Bauhäusler families who have supported us over the years.

BAUHAUS MUSEUM WEIMAR
THE BAUHAUS COMES FROM WEIMAR
From 6 April 2019

An exhibition organised by the
Klassik Stiftung Weimar
www.klassik-stiftung.de

Die Beauftragte der Bundesregierung
für Kultur und Medien

Freistaat Staatskanzlei
Thüringen

weimar
Kulturstadt Europas

Sponsored by

EFRE
EUROPA FÜR THÜRINGEN
EUROPÄISCHER FONDS FÜR REGIONALE ENTWICKLUNG
EUROPÄISCHE UNION

KULTURSTIFTUNG
DES
BUNDES
(Support for the Bauhaus
Agents programme)

ART MENTOR FOUNDATION LUCERNE

Sparkasse
Mittelthüringen

Sparkassen
Versicherung

Sparkassen-Kulturstiftung
Hessen-Thüringen

Media partners

arte
mdr
KULTUR

EXHIBITION
Concept Ute Ackermann, Ulrike Bestgen
Project lead Ulrike Bestgen
Curators Ute Ackermann, Ulrike Bestgen,
Anke Blümm
Curatorial cooperation Martina Ullrich,
Esther Cleven (until 2016)
Project assistance Sabine Küssner
Exhibition design Büro Holzer Kobler, Berlin/
Zürich
Graphic design Büro 2xGoldstein, Rheinstetten
Media concept Studio TheGreenEyl, Berlin
Visitor orientation and education Regina
Cosenza, Maxie Götze, Johannes Siebler,
Valerie Stephani
Conservation Uwe Golle, Konrad Katzer (lead),
Anne Levin, Alexander Methfessel, Laura Petzold,
Katharina Popov-Sellinat, Henriette Theurich,
Carsten Wintermann; Grit Broschke, Ralph
Broschke, Jens Kauth, Katja Liedloff,
Katharina Mackert, Corina Schmidt, Christine
Supianek-Chassay, Thomas Wurm
Showcase construction Firma Museumstechnik,
Berlin
Furnishing KSW: Sabine Thierolf (insurance,
loans), Olaf Brusdeylins, Uwe Seeber, Mike
Tschirschnitz, Nico Lorenz, Karsten Sigmund;
Fa. id3d-berlin gmbh
Logistic of objects Thomas Degner, Tobias
Koch, Kilian Niess, Michael Oertel, Robert Steiner
Finance Ulrike Bestgen, Claudia Ermann, Timmy
Ukat, Stefanie Landgraf
Issuing authority/Budget Anke Schmidt, Nency
Lorenz, Sandra Schöppe/Thomas Lessmann,
Ulrike Glatz, Hans-Jürgen Assmann
Public relations Franz Löbling, Timm Schulze
Marketing Rainer Engelhardt, Daniel Clemens,
Andrea Dietrich, Toska Grabowski (until 2018),
Melanie Kleinod, Antje Puschke, Ulrike Richter,
Manuela Wege
Security Alexander Stelzer
Real Estate Matthias Richter

NEW BUILDING
Competition Heike Hanada with Benedict Tonon, Berlin
Realisation heikehanada_laboratory of art and architecture, Berlin
Building construction Architekturbüro Manfred Schasler, Berlin
Project lead KSW Ulrike Glaser, Susanne Dieckmann, Johann Philipp Jung
Project lead assistant Gerit Rost

PUBLICATION
Editors Ute Ackermann, Ulrike Bestgen, Wolfgang Holler
Authors Ute Ackermann, Ulrike Bestgen, Anke Blümm, Maxie Götze, Heike Hanada, Wolfgang Holler, Johannes Siebler, Valerie Stephani
Translation Robert Brambeer, Titisee-Neustadt
Copy-editing/Proofreading Keonaona Peterson, Southbridge, MA
Image editing Heidi Stecker, Leipzig
Project lead, Hirmer Verlag Kerstin Ludolph
Project management, Hirmer Verlag Ann-Christin Fürbass
Design and visual editing Peter Grassinger
Pre-press Reproline Genceller, Munich
Paper Gardamatt Art
Typeface Chronicle Text, Madera
Printing Westermann Druck, Zwickau

© 2019 Klassik Stiftung Weimar, Hirmer Verlag GmbH, Munich; and the authors

www.hirmerpublishers.com

Front cover
Peter Keler, Bauhaus-Wiege (Bauhaus Cradle), 1923
Back cover
Paul Klee, Postcard for the 1923 *Bauhaus-Ausstellung*, no. 4 (The Sublime Side), 1923

Frontispiece Oskar Schlemmer, Postcard for the 1923 *Bauhaus-Ausstellung*, no. 8, 1923
page 6 Claus Bach, Roofing festival on 30 November 2017
pages 26–27 Museum façade, east side, 2018
pages 36–37 Façade, south side, after installation of LED lighting in November 2018

Bibliographic information from the German National Library The German National Library registers this publication in the German National Bibliography; detailed bibliographic data is available at http://www.dnb.de.

ISBN 978-3-7774-3273-1 (English edition)
ISBN 978-3-7774-3272-4 (German edition)

Despite our best efforts, it has not always been possible to locate the copyright holders for permission to reproduce the images. Any justified claims in this regard will of course be recompensed under the usual agreements.